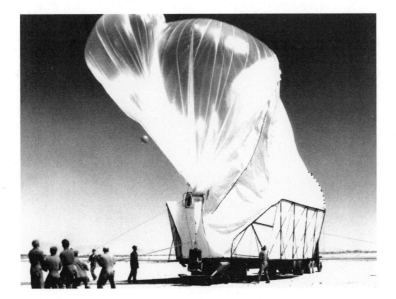

Sounding

ELLA FINER AND VIBEKE MASCINI

'Silent whale', the infrasonic blue whale voice at the heart of these letters – both provocation and underscore – is a sonic document held in the British Library sound archive that is inaudible unless sped up to frequencies within the human hearing range. How we encountered and continue to encounter this recording is also the story of how we encountered and continue to encounter each other within the letters that make up this book. We wrote to each other across three years, with varying intensities of correspondence; sometimes months would go by without a letter composed and sent. And in the gaps – the silences between the call and response of the letters – our conversations on other channels, across 'parallel streams', were also happening.

The overlaps in, and sometimes confusion around, what we have shared with each other and where (in speech, in writing) mean that the letters also refer outside themselves to sites of conversation we have no other record of. And so, like silent whale, itself a document existing outside our hearing range, these letters too are documents of other frequencies: of speech-in-conversation we can now only ever perceive partially or attempt to bring into audibility through writing.

The atmosphere of our first meeting, beginning Letter 20, is an example of such an attempt; the bright room – still so bright when brought to mind – held us deep in thought and conversation about energetic subjects. Returning to this first meeting which took place in January 2020 is to piece together flashes of shared and sudden wonder: fragmented memories of Vibeke describing her sound installation *Salvage*, a work harnessing the energy of a single stranded whale into a dedicated battery, and of Ella thinking out loud about a mute swan's heartbeat and other 'sonic miscellanies' in the sound archive.[1] We listened to each other talk about the connective force of listening to and through the sound of wild animals, so often communicating beyond our ability to hear, so often communicating more than we can in any easy sense attempt to 'know'.

Thinking back to this moment is very strange: the new year of 2020, when we were talking about the agency and affect of what cannot be held in hand, what cannot be seen or immediately understood. We were talking about whale voice, about what travels imperceptibly, out of human audible range, as signal, just as we were catching the news streams of a virus seemingly far away, its effects held at distance.

1 Vibeke Mascini, *Salvage* (2019). See www.vibekemascini.com/salvage. Ella Finer's development of the idea of 'sonic miscellanies' is part of her book project on listening and resistances to enclosure: *Acoustic Commons and the Wild Life of Sound*.

What begins the effect is always the tantalising question because the answer is never simple, and of course one story of the pandemic is its own difficult and now highly politicised search for an origin. In January 2020, the pandemic had begun – only here, in London, we were standing in the shallows. And now, writing ourselves back into this charged new year, we also contend with many beginnings: the multiple origin stories of these letters, some known, some maybe still unknown. Details are now frequently so blurred they feel closer to something like myth.

You might sense this in the letters as you read, that some key details do not connect directly to a source or have a clear origin. That silent whale, for example, is the only silent document in the British Library sound archive is something we now take as given, although we are not sure how this became part of the narrative surrounding our first encounter with the recording. This detail still hovers between fact and fiction.

Before Vibeke left for the Netherlands as the world locked down, we met at the British Library as part of a study group Ella organised around her project on 'acoustic commons and the wild life of sound', to collectively consider a politics of preservation across the archive and the commons. 'Does the sound archive hold sound beyond the human hearing bandwidth?' Vibeke asked. Silent whale was the answer.

And how did the infrasonic audio document of a blue whale come to be called 'silent whale' (a question Ella only thinks to ask, as if prompted by closure, in her last letter)? We are interested

13

in this: in the loss of the originary explanation, the ways the past adjusts as we attempt our returns. But this detail we can recall: it was Cheryl Tipp, curator of wildlife recordings at the British Library sound archive, who in an email to Vibeke, early on, wrote: 'I am just about to send you the "silent whale" recording ...'.

The letters began in response to this strange audio document, the 'silent whale' recording, in the context of Vibeke's residency at Delfina Foundation in London. Unable to continue our conversations in person, Vibeke proposed that we write instead, with the silent whale as our channel for communication, a rationale for keeping in touch. Letter 1 is her call; Letter 2, Ella's response – a reciprocal call – and so on, as our letters lead into and out of each other's receiving-writing, listening with and through silent whale and other so-called silent subjects.

We agreed early on that we would write 22 letters, however long it might take us to meet the end. A correspondence with an end in sight always proposed something of interest for us: how we might compose our thoughts for a beginning, middle and end of a conversation across distance. Now, as we read ourselves back, we sense how the writing moves from the buoyancy and swift pace of infancy – through time – to our expression deepening, both in relation to silent whale and to each other.

The whale voice – the loudest, most energetic of animal voices – travelling across oceans and met by many receivers offered us the method of approach here. Our correspondence was no enclosed channel: these are letters written dedicatedly, intimately, to one another while open to their other readers. In this

way we have always been interested in how the letters move beyond what Kate Briggs has referred to as 'the protected space of two', and especially the conditions under which letters become public – what then can the fiction of privacy do?[II]

When we first met with Kate about this book, on another bright day, the *Silent Whale Letters* had already moved from Delfina's online platform (from Letter 1 to Letter 3) to Ocean Archive (from Letter 4 to Letter 20). Kate is also in correspondence with us here, revealing in ever more expansive ways how the practice of editing is also one of conversation, of deep reading and writing in fellowship. The final two letters were always intended to be written 'offline', made public only when all the letters could come together in print. In this way we left the letters provisionally ended: suspended and floating in the Ocean Archive, along with four invited correspondent microessays by Astrida Neimanis, Chus Martínez, Pablo José Ramírez and Tanvi Solanki. The remarkable diversity of response in these pieces move through Martínez's deep-sea letter of complaint, where 'Language is a very precious event down here', Solanki's consideration of the silent letter 'h' in 'whale', revealing how 'sounds exceed the capacity of inscription', and Ramírez's focus on silence and its equivalence 'with everything that cannot

II Kate Briggs in conversation with the authors, Rotterdam,
6 September 2022.

be named'. [III] Neimanis's reflective translation of a necropsy, laying bare that 'No record can hold everything', strikes a tender note at this point: the end of our writing, the beginning of your reading.

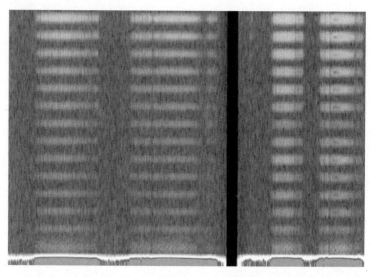

Spectrogram of a blue whale recording in the British Library, London. Recorded by Mark A. McDonald, Antarctic, Valentine's Day 2002.

[III] The four responsive micro-essays, commissioned by Ocean-Archive.org, can be found at www.ocean-archive.org/story/silent-whale-letters.

No record can hold everything. This spectrogram image holds the sound of silent whale in the visual representation of its spectrum of frequencies. In this way the image holds a space for the inevitable interplay of silence and sound, a space we continuously speak with and through in the letters, gesturing implicitly to the impossibility of hearing the whale, because always manipulating the record to perceive the presence of sound. The trickiness and instability of the document and the record is a part of what we reckon with, and maybe especially here, in this opening, when we become aware that any web link we provide to listen to silent whale will at some point lead to nowhere, will fall silent in the way that links tend to do. At the time of writing you can hear silent whale on the Delfina Foundation website. [IV] If, by the time you read this, the link is broken – the silent whale silenced by time and circumstance – please imagine the sound through our approximations in words, in these letters.

IV Listen to silent whale on Delfina Foundation's website, in the context of Vibeke Mascini's residency project INFRA, which began the letter correspondence between Mascini and Finer: www.delfinafoundation.com/ platform/vibeke-mascini-infra. For more information about the recording in the British Library Catalogue, see http://sami.bl.uk/uhtbin/ cgisirsi/x/0/0/5?searchdata1=CKEY6685257.

O YES

Vibeke to Ella
The Hague, 14 April 2020

O yes, I too recognise this strange experience of time now that everything takes place in the same spaces, under this surreal slumber. While the virus mostly seems to inhabit the world outside my own family, home, skin, certainly its effects have permeated all of them. Could these be frequencies of some kind, infra or ultra?

The 'silent whale' still occupies my thoughts. Indeed, the only 'silent' sound recording that resides in the British Library is the infrasound voice of a blue whale. Lower than our human ears can perceive.

Of course, sound is not merely a sonic experience to whales, it's part of an entire constellation of senses corresponding with phenomena beyond our wildest notions. Sound is also a visual experience; it is known that by emitting and receiving sound frequencies whales can visualise shapes and marine landscapes thousands of miles away. When a whale's voice reaches another whale, it is not like light: sound doesn't bounce off the surface of the other whale's skin, in the way our eyes perceive reflected light and create an image. Sound can actually, effortlessly, pierce

the skin to reflect an image that is part-external, part-internal back to the receiver. Like an X-ray rather than a photograph. This way a whale might see its friend from a far distance, while simultaneously seeing in its stomach what it had for breakfast.

I'll forward you the spectrogram images from the 'silent whale' recording which sound engineer Tom [Haines] sent me. On these diagrams of sound frequencies we can see what we can't hear. I'm sure you are more familiar with reading these visual sound analyses, but it shook me to realise that the density of colour indicates acoustic energy, and that the bright colours at the bottom of the diagrams convey how energetic, how LOUD, those silent sounds actually are! This of course is no surprise as these sounds are intended to reach across oceans.

Thank you so much for your update on the event this fall. Wouldn't want to miss it, in any shape or form. Whatever happens these upcoming months I'm convinced we will become a species well adapted to communication over vast distances as well.

Sending many hugs!
Vibeke

A SONG
THROBBING UNDERWATER
(I FIND IT FRIGHTENING)

Ella to Vibeke
London, 24 April 2020

Thank you for your letter and for inviting me to correspond and think out loud with you about not-so-silent subjects. I can imagine the blue whale song occupying your thoughts in so many ways. Haven't we been haunted by the still silent whale of the archive – the unheard silent whale – the whale record we never had a chance to hear in the archive before the world changed so rapidly? When you returned home from London, what was it like receiving the blue whale recording into a completely other space and time than that in which we had first become aware of its existence? Curious to think of this recording travelling through the internet, to span distances the animal could reach through its song alone in the ocean. I listened to the recording you sent, the sped-up frequencies allowing us to perceive something audible of the whale's low, pulsar rumbling. It is cosmic and chilling – the hollow acoustic space coming by increment into audibility – a song throbbing underwater. Before heard, felt.

21

I am so struck by how you describe the spectrogram images of the sound as seeing what we can't hear. I feel I am apprehending the world the other way round from this right now – hearing-as-apprehending what I cannot see, both close and at a distance (not unlike the whale you describe visualising land at a distance through sound). The recording of the whale moves me so intensely. I find it frightening (I never thought that would be my reaction) in its acoustic scale, which is so different from the effects of volume or amplitude. The deep vibrations of the whale occupy all the air space in my headphones long before these vibrations become something like a clear sonic signal.

I mentioned a dream I had in another message to you, and (even though I cast myself as a film-maker, in homage maybe to Andrew Kötting and The Whalebone Box[1]) it speaks to something I have been thinking about in relation to the whale recording, about how we attune with/to unclear or uncommon sound, especially in unclear or uncommon times. How do we cope with, deal with, let alone attend to subjects we cannot hold in hand, can neither see nor hear? Or subjects that appear as such? Subjects that shape-shift, change scale and frequency, medium and channel?

In sleep I was standing between dark rocks, staring out on to a deep violet sea, an old friend standing next to me while thinking of a new friend, you. This dream-image was a flash, a moment of exposure before waking – a moment that told me I was making a film called (… ahem) 'The Whale in the Sea'. Neither the whale nor you appeared to be there, at least not

'in shot'. The sea was as still and quiet as my body as I listened out for what I was unable to see. And in a vivid instant I knew you and the whale were there – relying on, as I have written elsewhere, 'keeping faith in the absence of fact, of feeling the trace elements of something in the air, on the air, of listening to the materiality of vibrations and hearing imagination as information'.[2]

I'm sure the moving stills of my rapid thoughts while sheltering in place are not uncommon in this time: such speed in confinement, such volatile experiments in thought and feeling, in small rooms, asleep, awake, asleep, awake. And what do we perceive in the audio playback of our sleeping minds 'under this surreal slumber', as you call our current conditions? In Dylan Thomas's 'play for voices', *Under Milk Wood* (1954), the scene of sleep we first encounter is an auditory world, one which we are invited to listen in to – not only to the still natural world of the unwoken, the 'dew falling' and 'salt slow musical wind', but also those asleep: the First Voice tells us, 'From where you are, you can hear their dreams.'[3]

With love and strength,
Ella

AN OCEAN THIS QUIET

Vibeke to Ella
The Hague, 29 April 2020

The acoustic scale really is striking. Estimates tell of a time – before commercial shipping and other motorised noises entered the world ocean – in which a whale's voice could be heard at any location and at any moment. How spacious this global symphony is. (Speaking of acoustic commons!) And to think that the underwater environment was considered a silent one until midway through the last century; the absence of hearing mistaken for the absence of sound. Surely the oceans have been more silent than *usual* now. Like people have retreated from streets and plazas, so have they from the open waters. The oceans have, in part, been emptied of human-propelled noise, which has an immediate effect on whales raising their voices. Generations of whales have never experienced an ocean this quiet. 'We have an opportunity to listen,' says marine acoustician Michelle Fournet, 'and that opportunity to listen will not appear again in our lifetime.'[4] Does it really take a catastrophe to listen?

I'm drawn to your description of the 'hollow' space embedded in the 'silent whale' recording as 'increment', like a third

actor present in sound. I too experience this hollow space, this ocean space lucidly. While the whale is still actively present in the recording, as it emits sound frequencies, be it unheard ones, the ocean might rather be the 'silent' actor. But if silence refers to absence, not even that appears to be true. The ocean *is* present on the recording; we experience its vastness in deep abstraction, as the fabric through which the whale's frequencies travel, as the fundamental factor that shapes its sonic texture.

When we become quiet, we can attune to other (than human) voices.

Our friend Michael [Morris] worded the outer-worldly familiarity of the 'silent whale' frequencies as 'the sound of deep sleep. An audio-only dream.' Interestingly, he, like you, referred to a dreamlike state. These weeks I experience very vivid dreams as well, and it's something I've been hearing from many people around me. As you also attest with the examples of your email, this might really offer an interesting track for your thoughts on how we attune with/to the *unclear or uncommon* right now: we dream. We submerge in imagination with all available weight. I would really love to hear more about your observations regarding the line of thought you mentioned.

Also, I realise that as a parent you must be well familiar with the weight of a dreaming body, as a child's body can (and o so deeply enjoys to) be carried asleep. Is it heavier or lighter than the body during daytime? I might be wandering off. I guess whales and (their) weight have been such active themes in my

thoughts for years now that mentioning one triggers the other without the slightest effort.

Much love from across the water,
Vibeke

HOPE
AND NO-SENSE

Ella to Vibeke
London, 25 August 2020

Here we are nearly four months on with the weight of our dreaming bodies now strangely familiar to ourselves. Familiar to me, at least. Are your dreams still as vivid? I love how you end your letter by asking about the weight of small sleeping bodies in motion – through day and night – in relation to the colossal weight of whales, especially living with children who wake up with the sun, full of bright, buoyant energy. I wonder if you know that the name of the blue whale skeleton, suspended and floating in the air of the Natural History Museum's entrance hall, is Hope. I cannot help but hear the multiplicities of meaning in *the weight of suspended hope*.

This morning I could hear the distant glimmering acoustics of wide-awake bodies – background noise – while I experienced a deep, heavy quiet and stillness, as if a giant rock was tied around my middle, holding me to sleep, holding me in sleep. And in a near-waking dream I found myself in a small stone room with a wooden shelf, a squint of light – I have been reading about anchoresses; among them, some who committed

27

themselves to solitary days-into-nights in the ground that would become their grave. I have been reading too about the whales dying on beaches in extraordinary numbers – confused maybe by military sonar exercises and surfacing too quickly, causing decompression sickness. The bends. We spoke of beached whales when we first met, these giants of the ocean, unnaturally grounded. Large objects so out of scale with the land. You showed me some of the experimental logistics for (re)moving whales once they are weighted to the world. I love how, in your work, you seek out and create other conditions of buoyancy – of lightness – for the very heaviest of bodies.

Listening to the whale call is one such way to perceive *by ear* the buoyant body in or through water. As you write in your letter, we are hearing the relation of vibration and medium, the song through the fluid which calls attention to the vital need for depth and lightness – for buoyancy. And I am so struck by this 'opportunity to listen' to the ocean, to the quiet which, four months later, sadly, does not appear to have lasted so long. I wonder how these theories of military sonar and seismic surveys for oil fatally affecting whales around Northern Europe will develop. What on earth is happening that we have no *sense* of? When we see the effect and cannot hear the cause? We have talked about the power of what we cannot hear in relation to the agency embodied in whale communication outside audible frequencies. The right to remain unknown, underneath the surface. When I consider the scales of destruction, of violence, inflicted by human-made vibrations and

28

frequencies we cannot hear or feel with any clarity, my ears respond with a high-pitched tone. This happens sometimes.

You began your letter with a time when the ocean was considered a silent place. This reminds me of my father's composition *Starfield*, made with the sound of stars; of the sonorous universe, he writes, 'we can listen to an interpretation of a star's harmonics. Every star is ringing like a bell.'[5] As you say, these are striking acoustic scales, these distant movements at multi-dimensional depths. Bells in the sky, songs in the sea – this is me dreaming.

Much love,
Ella xxx

THE VOICES THAT
TOUCH ON, CARRY AND
ENTER THE BODY

Vibeke to Ella

The Hague, ~~19 September 2020, 7 October 2020,~~
~~17 December 2020,~~ 19 January 2021

Something that struck me the other day: that the first sound either of us heard would have been under water. Submersed inside our mothers, ears filled with amniotic fluid. Would it have been the pulse of her heartbeat – sound coming from the inside – or some outside voice reaching us, muffled to round tones and bringing into minute vibration that in which we floated? Would we have heard it with our skin?

'Like blowing on your hand',[6] as a sensation resembling how echolocation feels underwater, the sound of a whale's voice as a touch on the body. It also makes me wonder how the sound of stars might move us. What would the equivalent feeling be of 'every star ringing like a bell'?

I enjoy tracing back our lines of thought as I reread our email exchange. By now this conversation on sound – as movement, as energy, as sight, as commons, as silence, as noise, as pulse – has nearly lasted a year. In part because this letter of mine has

been often started but barely finished, but more so because our conversation over the last months has continued in phone calls, video calls, text messages, Google docs and along many other signals, channelled through air and pulsing in copper and fibre-optic wires ... and it never fails to bring into motion new ideas. Quite the opposite; it has been the constant hummm in the back of my mind, a comforting kind, like that of a refrigerator stocked with Christmas dinner leftovers, or perhaps also like *The Waves* on the shore.[7]

> Along these singing lines that run
> from pole to pole, supporting heaven
> I send along to you my portion
> of earthly dust
> 　　　　　From wires
> to poles. This alley sighs
> the telegraphic words: I lo-o-ve[8]

Some time ago you asked me to write more about the video I sent you, showing the silent whale's voice (the Hope of the British Library) travelling to the surface of water in a paper drinking cup. It is part of an installation I'm working on in which the presence of the 'silent whale' will be central; the information on that recording might not be available to us sonically, but possibly by means of touch, or sight. Within an empty cellar, I'm currently assembling the right conditions in which we could sense the whale's message on our skin and in our guts. The

rippling water in the paper cup is the witness to the so-called silence, 'the shape of the world between us', to direct us to the limits of our sensorial reality and that which may exist beyond.[9]

Most of our conversations have been about that, a reality beyond ours in one way or another, which makes me doubt to bluntly put it like that. Like you said, 'What on earth is happening that we have no sense of? When we see the effect and cannot hear the cause?' I still need to find the words to describe this experiment that for now barely exists within the enclosed walls of my studio, waiting to take up the hollow spaces that are still under lockdown.

Much lo-o-ove,
Vibeke

COMPOSING IN THOUGHTS ALONE

Ella to Vibeke
London, 13 March 2021

I have been composing this letter over the past weeks in thoughts alone – far from translating my thoughts into writing, or (that expression I find more and more curious) *putting down in words*. We have both taken our time over this year to write *down* – maybe we hesitate a while at placing our thoughts? I do. And then I think about the letter as a form that holds the words buoyant between us: leaving me to reach you, and, through reaching you, reaching me again in turn.

I think about the writing *down* that plays resistantly with the physicality of being down. When words flex, their sonic possibility breaches the page. I find this in your last letter – I love Tsvetaeva's telegraphic stretching of 'lo-o-ve'. A vocalic spelling, a vibrant unsettling of the familiar. I immediately try to say it out loud.

I love also how the poem is structurally placed in your letter, almost as that extra -o- holds the midpoint, pulling love to new limits. The -o- as that point on the meridian that shows the shape 'from pole to pole' to be an arc. The -o- as the element that pulls the sentiment further.

I love how this poem shifts my attention and returns me to reading your letter with a new sense of all our letters' dimensionalities – how even these breaks or turns between writing, as you detail, are so abundantly full of response; how the break, like the -o-, is both a connective and distinct frequency. It's the hummm you hear in the background.

Maybe also this hum is the richest kind of memory material, full of what we hear ourselves composing to each other, full too of the frequencies of the bell-stars, of amniotic acoustics, of the silent whale. These frequencies which, as you write, move us.

You write of the tiniest of human bodies learning the world through water – muffled sound, rounded tones and outside voices. And when you turn to the internal sounds of the voice-heart-body that touches what she holds inside, I think about the piece we wrote together in the winter, in which the mother and the mythic whale make space for other bodies inside their own.[10] Giants.

And now I learn Hope – the suspended blue whale skeleton – was, in her last year of life, pregnant. I think of that great ribcage and all it has held and now holds in the museum's grand hall. I imagine the air in the building – a zoo of ancient particulate matter – now swirling in the belly of the whale.

Look up.

You know when light exposes a sheer pane of sparkling dust? This fast revelation of what is usually out of sensory perception – a light that at the right angle can show the populated air. Is there an acoustic equivalent? How to hear a cut through

the frequencies we live with and in? Maybe this is in part answered by the silent whale becoming audible to our human ears at speed. I wonder what an orchestra of frequencies brought into human range might sound like.

Your subterranean experiments with the whale brought to life in the cup of water attend so beautifully to this curious practice of manifesting frequencies, of making the vibrational effects materially felt. How much of the affect of the whale body is in this audio record? How much of the body?

You are taking the frequency underground, taking it ... *down*. Thinking about this taking down of the silent whale in the same space as I consider the lifting up of Hope makes me wonder about where we put the whale in the world, where we place it, symbolically and physically. This is reflecting back in many ways to how our conversation began when we first met: once out of water, where does the whale go? It strikes me that the two whales present in these letters – the silent whale and Hope – are preserved documentary elements, both held by cultural institutions. They represent whale matter in varying degrees as natural curiosity, collected object, scientific specimen, evidence. And yet the whale out of water proffers questions not only of preservation but also of disappearance, of dispersal. As you attend to in your work, the problem of how to remove a giant body from the beach often becomes one of how to render it invisible. I have been reading about whales buried in place, unconsenting anchorites on the beaches they are stranded on. When the scent of the decaying body attracts sharks to shore,

again we are reminded that rendering invisible does not so simply make absent.

In the space of this last turn of our correspondence, in the -o-, Christopher Heighes told us both of the interwar South Kensington burial pits, temporary whale sand graves in the Natural History Museum grounds. When decomposed to bone, the whale skeletons would be added to the museum's collections. I can't help think about the scent of these burials – if not perceptible above ground, then permeating subterranean London.

To 'take something down' is also another way of saying to put on record, to make a document. I am interested in your own sense of taking the silent whale down, turning the audio record into something like a living document, a wilder life for the wildlife recording. I can only imagine how the vibrations of the silent whale will move in, through, beyond the cellars you are working in. I cannot wait to hear.

With much love,
Ella

Het Hart in Haar Mond

A child looks at a stone crucifix and says she has seen the Statue of Liberty. As the child's voice finds its language in images of life beyond human scale, her mother returns to her early years. To learn language again in sounds, to learn the world she lives in by touch, to feel the news as painful rushes of sound and vision, to see the symbols of freedom, liberty, sacrifice in the same image-collision. She makes the challenge to herself – to find the words to explain how they are distinct.

She calls the voice, in which she learns the world again, her singing voice. She is familiar with the recycling of air and knows her voice carries in the inhaled/exhaled breath of others. She knows that a singing voice severed from the vital intake of air would be very different from hers, which is always rooted in the impulse of breath. While the humpback whale can 'sing' without blowing a single bubble, her singing voice always short-circuits with the need to take in oxygen – she makes conversation in the suspension time of the natural need.

Some voices make their meaning beyond what we can hear. Would we still call these voices? These languages taking shape

in energies, feelings, intuitions; or the submarine vibrations of the whale song? She thinks how to describe the distinction between the natural and artificial voices that can occupy the same frequency, 'voices' that carry such differing intentions. The military sonar that met the voice of a whale in the 1940s was listening for enemy craft when it intercepted the animal's whistles, squeals, chirps, clicks and rasps. She can't imagine the human voice sounding as ethereal to the whale as whale voices sound to us: when whales might perceive our voice as the sterile pings of the submarine and the monotonous hum of the motorboats. This human voice has become the background noise to all whale communication, obstructing vital sound frequencies. At times, when this mechanical human speaks, whale ears bleed.

This is wave study – how we make returns and trust the slips. When the water rolls differently we trust the wave to carry us, but we are not the ones out at sea.

The man in the whale body lights a fire. The whale body never sleeps for fear of drowning, or not fear, but deep knowledge. A profound understanding of breath, a remembering of air as the breath that will sustain it. Is this why the fire is able to light and burn? Because the whale breathes the same air as we do, and the 'air will never simply be mine'.[1]

1 Luce Irigaray, *The Forgetting of Air: In Martin Heidegger* (London: Athlone, 1999), p.309.

The imagined whale-walls hold the dream-hollow in which the fire burns. This mythical architecture of the insides, this need and desire for the human to take refuge inside the mystery. And how we try and make sense of the mysterious through scaling with what we can apprehend, what we can – by touch – start to form the dimensions of. The whale heart is the size of a small car. Who drives the whale heart? The blood that pumps through this giant organ is laced with heavy metals, battery elements. *Who drives the whale heart?* This heart that can be heard from miles away.

The mother abstracts distance for and with the child. Stories happen far-away, time is once upon. She returns to storybooks to learn to read again, about another metal giantess, an iron woman awakened from deep sleep by children, who, through her, hear the dying of the world. The mother of exiles, liberty in pylon and steel. Imagine making the metal skin for your mother's likeness. Building your mother as a giant, she who is always that scale. Mother giant.

Giants of land and sea, their hugeness makes them unfathomable. And still the human searches. An underwater research vessel films its way down through green water, particles rushing upwards as the camera descends. A robot arm picks a flower of the deep; and she searches for the words to say this is not the only way to understand the world.

The vertical coral reef the researchers find – standing like a monolith, a mid-ocean needle – is 500 metres tall. As tall, we are told, as the Empire State Building. Again, this deep-sea

resident is granted human scale by comparison. As if we could climb to the top of the coral and take our picture; as if we could attach zeppelins to its pinnacle. As if we could call this extraordinary structure, of depth architecture, the *Empire State*. One blueprint plotted by a single architect for a tower constructed in 410 days; the other plotted *in the blue* by many marine architects, gradually forming across thousands of years.

The mother searches for language to make these two towers distinct and cannot: the seabed of northern Australia and the streets of Manhattan give rise to skyscrapers/seascrapers, not so unfamiliar to each other after all. Both their spines share an oceanic memory, a deep-time material memory of millions of years. The limestone embedded in the skyscraper was formed from shells and other biomineralized parts of creatures that inhabited a sea once covering the state of Indiana. We live on the remains of ocean life of past geological ages. Coral builds on its dead until a limestone reef is formed. 'Limestone, and its metamorphosed form, marble, have been important building materials since antiquity. The pyramids are man-made mountains of limestone.' [II]

Whales do not inhabit a stationary environment, living in a society 'completely without material infrastructure or record'. [III]

II Bernd Heinrich, *Life Everlasting: The Animal Way of Death* (Boston, MA: Mariner Books, 2013), pp.166–67.

III John Durham Peters, *The Marvelous Clouds: Toward a Philosophy of Elemental Media* (Chicago: University of Chicago Press, 2015), p.79.

Whatever material changes cetaceans might achieve would have to come in the shape of the only matter they can mould: their bodies. And from and through their bodies, *their song*. With coral, 'their dead stay with them; they live atop the skeletons of their ancestors', building towers that may near-breach the sea's surface.[IV] Do whales record their ancestry in voice, gifting their stories to the currents, their slow heart beats to the waves?

In the stories she returns to, whales are immortalised, re-corded on the page; while in the city she walks through, whale energy pulses. The buildings made from marine-life-turned geological building blocks and the electricity that lights their offices, from the burning whale. A city underwater.

And now, she looks at buildings and sees coral spikes. And now, her burning candle is alight in the belly of the whale. And now she sees the shape of it – and still can't find the words –

Ella Finer and Vibeke Mascini
December 2020

IV Alexis Pauline Gumbs, 'Being Ocean as Praxis: Depth Humanisms and Dark Sciences', *Qui Parle: Critical Humanities and Social Sciences*, vol.28, no.2 (December 2019), p.340.

WORDS FLEXING

Vibeke to Ella
Tourtour, 22 July 2021

Shape the three middle fingers of your right hand in a W, while keeping your left hand horizontal like a shelf (or a windless ocean surface) in front of your chest, palm facing down. Now point the tips of your W-fingers down and slowly, smoothly lift that hand up to your face, where you slowly, smoothly flip the tips of your W-fingers to the sky as you move your hand back down again. It's how a deaf person once signed *whale* to me. A silent hand, diving into a still ocean arm.

~

It's mid-July now, a warm summer afternoon, many months after your last letter reached me. I've become messier in my communication lately, being tired of digital screens and resisting the need to plan correspondence with dear friends during already over-planned days, hoping for chance and surprise encounters that fail to take place. I increasingly find myself apologising for so-called *radio silence*, a term that among maritime radio operators is used as a directive to listen for 'faint distress

45

signals'. What faint distress signals have you picked up in the meantime, I wonder.

In a reversal of the 'putting down in words' you mention in your letter, I sometimes wish to translate writing back into shapeless thought again and let it cast away like smoke.

My current list of necessary things I fear to forget, my to-do list, is a five-page document on my computer titled '26 August 2019', which makes me realise I have accumulated this ever-growing number of things for nearly two years now! On the upcoming 26 August I will delete the list; all things must re-member themselves after that.

In an interview the poet Ocean Vuong mentioned how when he wants to describe something, he postpones the moment before *putting down in words* as a way to observe more intensely. Perhaps for something to convey itself more freely, excessively, rid of the logic that language aims for. There is something so wonderful about that liminal space in which something is recognised but not yet worded, or not anymore, free from having a word body.

In Dutch we speak of putting 'dots on the i's' as the act of completing something. The little dot that in handwriting would often be added after the rest of the letter has already landed on the page. A Taiwanese friend told me that he knows a similar expression which speaks of 'dots on the eyes' (the spoken difference between 'i' and 'eye' initially causing a funny misunderstanding) as the final touch of a painter finishing a portrait.

I love the image you bring about when you speak of words

46

flexing, as if to activate, to keep from stiffening like most un-moved bodies. Perhaps this is the challenge to a noun-oriented language, describing a world that appears to be fixed. How our perception might change when we think more in verbs than in nouns is something the botanist and writer Robin Wall Kimmerer drew my attention to. In Potawatomi, the native language of her tribe, 70 per cent of all words are verbs (in relation to 30 per cent of English words), and different verbs communicate relations between 'animate' and 'inanimate' subjects. This means in her language you '"hear" a person with a completely different word than you "hear" an airplane.' [11]

If only that would distinguish the sound made by whales, keeping it from being enveloped by the louder sound on similar frequencies of cargo ships and other sources of ocean noise. Sadly, there seem to be no animate and inanimate divisions when it comes to ocean soundscapes, where the sound waves from speeding ships can cover or cancel whale communication.

A strategy of combat becomes clear in that the 'silence' of noise-cancelling devices involves creating more sound waves rather than fewer.

The body of sound, referred to as waves and shaped as resembling the saline ocean water. 'How much of the affect of the whale body is in this audio record? How much of the body?' you write, and I thought of this question as I read the extraordinary work of Rebecca Giggs, mentioning how some fin whales emit such deep sounds that the wavelengths of these frequencies can be longer than the bodies of the whales themselves. [12]

And those few ripples of a postmark that you drew my attention to long ago (sometimes a stack of three, sometimes of five): do they echo sound or water? Or radio waves? Or perhaps they hold an exact measurement perfectly fitting a body.

Sending much love,
Vibeke

PS I will write to you about the subterranean silent whale in my next letter, for there is much to say.

SLEEP AND THE SEA

Ella to Vibeke
London, 15 October 2021

... all things must remember themselves. And have they, since 26 August 2021? Have they shown themselves to be remembered?

I saw Dorothea Tanning's painting *Self-Portrait* on a friend's fridge – a postcard I sent years ago, with young handwriting and an image long forgotten, even if one I had deeply loved once. The figure in the landscape faces out, alone – hair rolled, lower arms held close to her chest. She stands between dark rocks. Sleep brought the image back some months ago and I wrote to you about it – I flooded the scene with violet sea and met the figure standing as an old friend. All things must remember themselves. Yes, I love how sleep returns to us things we may have thought disappeared: images, ideas, people. And how we may not even recognise we are being reminded; nor even recognise the things we are being reminded of. I now look at that painting and wonder at having been inside it.

Dream and image fell together – as you said – in early spring, and now it is autumn, now it is fall.

This feels the season for smoke signals, for casting words as written out into cold morning air. We can breathe small clouds

49

to each other, watch the ways we make weather, and try translating writing into a form where it is again 'not yet worded'. Remember how we looked at the patterns of wind and waves between us on a live weather-charting map, so taken with the visualisation of our connection carried by the currents?

I understand your wish to turn words to shapeless thought again; it's a privilege to read those who give the restless energies of present-tense feeling a moment to land in writing. I have always liked the word writing as a noun. A continuous thing. And as writing pulls the moment of its happening through to the many moments of reading, it is so charged with the experience of a writer telling their time. A tender practice, turning the moment to words and sending out.

These letters, an open correspondence, reach out beyond you and me, and I wonder then how these future 'fossils of feeling' might be found again to us, when – through email – we can already see what is received as well as sent.[13] In the wider technological and cultural turn to digital correspondence, the sent no longer lives on at such distance from the writer's body; retrieval a small magnifying glass away. I think of email replicating the sense of carbon copy without the paperwork, and Sylvia Plath's letters leaving as 'carbon birds' – carbon materialising both acts of preservation and dispersal. Remembering Plath's three bonfires, burning 'papers that breathe like people', I am drawn to thinking about what is so differently at stake in letter writing when we keep hold of what we send.[14] Without the chance to allow another the fate of our feelings; without

the chance to forget where we have sent parts of ourselves, or in whose care parts of us remain and whether they still do.

And where, now I read myself back, is the whale in this letter? Unwritten, even if swimming in the shapeless thoughts, in the feelings fossilising in these sentences. Silent, I imagine, in the way we know silence to speak of bodies – how silence speaks in the speed of the archival document, in your beautiful descriptions of the right-handed W, the deep frequencies longer than whales, the loudness of noise cancellation; and in the dream I have now found the living image for in forgotten correspondence. The dream in which I knew the whale was there; when I knew you were there too.

Strange to be ending without remembering so much of what I had wanted to write, so I will end without ending – channelling your conversation of dotted i's and eyes into the following image of a suspended 'final touch'. The figure in Tanning's self-portrait looks out into the landscape; she has her back to us. Hers is a body with no eyes to dot.

With very much love,
Ella

ELABORATE SONG AND ELABORATE LISTENING (MY FATHER'S LANDLINE)

Vibeke to Ella
Amsterdam, 31 October 2021

Another carbon bird, catching up with the flock!

Writing to you in this season of smoke, in a month when we both have celebrated our personal orbits around the sun. Happy birthday to us! The tender smoke signal of a wish made with the blowing of candles on a cake. Our mouths, making weather and wishes.

I've moved into a new apartment, on the top floor of an old Amsterdam house, just below the roof. The view from my windows displays a landscape of central heating plumes as temperatures drop. Under this roof, a calm breeze is amplified to sound like a storm, making me aware of the wind in a new way. We spoke about the wind before, the wind tearing on hair and coats; the wind carrying messages; the wind between us. Perhaps the wind is to blame for us not having spoken over the phone lately, for its sensitive mic can falsely mimic in catastrophic proportion the wind gently brushing beside it.

Things that remembered themselves: the number of the landline to my father's house. It is probably the first thing I

actively remembered, archived on the spacious shelf of my child memory. I continued calling it until recently, but my father never picked up anymore. After some time listening patiently to that calling sound, I would often turn and call him on his cell phone instead. The other day my father told me he hasn't owned that number for more than five years. Where was I dialling into, then? Could it be a specific location, if even somewhere in between? And what do I do with the memory of a now meaningless code? I wish to ask a century-old person.

> You cannot play air with hammers. You have to play
> with butterfly wings. [15]

I blindly scribbled this note down in the darkness of a cinema the other day while watching (and listening to) *Sisters with Transistors*. This documentary describes the challenging of categories that early electronic compositions posed to the musical canon. Especially if the composers of this often ambient and non-melodic sound were women. It left me thinking of the relation of noise and song, and voice and song. When is naming something *song* over *voice* a distinction of attention and care and when is it an unfortunate degradation of flamboyance over the urgency of communication?

Of humpback whales it is known that their so-called song – a complex sequence of sounds – changes over time, and that alongside their bodies a specific song migrates and is passed on to other whale communities. It wasn't the observation that

whales sing elaborate song that made scientists speak of the presence of culture among these beings but that the same song is shared with and copied by other whales across the oceans. This doesn't only involve elaborate song, it equally requires elaborate listening, and how a community listens is what creates their culture.[16]

We keep on listening to the 'silent whale' and it appears we are still perceiving new dimensions of its infra-sound as we move with it. This transformative way of listening – of 'reflexively extending' towards frequencies over time – is what I believe the sonologist Raviv Ganchrow refers to when he speaks of 'hearing as a site rather than a condition'.[17]

I wonder if the former whale songs – the now unsung ones – are remembered by the whales as documents somehow. Is there any use to remembering them, I wonder. Besides the obvious, more dispersed way of being remembered, by the body that has been informed by these songs, the body that has been moved by these songs, as a singer and as a listener.

When I press 'send' in a moment, and with that decide the final shape of my words for now, this *carbon bird* will follow the gust of wind emitted by my speakers, whooooooossshhh, and set off.

With ever more love,
Vibeke

IT IS NOT OUR WORK
TO STILL THE ENERGY
OF THESE MYSTERIES

Ella to Vibeke
London, 15 November 2021

I am writing with an ocean in each ear. Pacific and Atlantic meeting in my body as I meet your words speaking through the atmosphere of a new home.[18] Again, I think of how we find each other at distance through such currents: the tumbling wind of your roof and the high-pitch whistle my windows make bringing us elementally closer in the attention we give to acoustic affiliations. We *keep in touch* this way, finding the correspondences of what we are experiencing. When we hear the air move or we swim in cold October water; when we send pictures of the coast on which we are standing only a few miles apart. And so I listen to these oceans that meet at the southernmost point of South America – and for this moment at the imagined midpoint between my ears – as a most beautiful auditory gift, of currents and correspondence, between and in bodies.

As I listen to the in-ear oceans, an ode to an Octopus Goddess,[19] and consider the whale communities you describe, a coincidental correspondence appears from the other side of the

city. My friend James Wilkes sends photographs of the pages he is reading. 'Things do not connect; they correspond' – he pulls a line from one of Jack Spicer's letters to the ghost of Garcia Lorca.[20] I send the pages on to you (a parallel stream) and you ask if the hands holding the book are my own. We can hear each other in the wind but we cannot remember each other's hands. I was once asked by a homeopath why I kept looking at my hands. *Because I can see through them*, I thought, but said nothing.

Since you wrote of calling your father's stranded phone line, and whales' unsung songs, I have been thinking of your question about what we do with once meaningful information – imagining scenes of telephone exchanges with fast hands operating the switchboard of all our real and imagined, made and lost connections. The number to nowhere-you-know still rings out, somewhere. And while the number loses its practical use to reach your father, *to dial it is still to reach*. The meaningfulness of the code adapts *reach* as a *reaching out*, continuous. So while the code is not so efficient in finding the person and the place, it does something else – in using it, you call out, keep the motor going. Sometimes that is enough, when those we hope to reach feel it. I love that somewhere a phone is ringing for your father.

And the whales – are their now unsung songs remembered? I think of whales, through your writing of their remembering bodies, as archival animals. And when I read Rebecca Giggs's description of the whale out of water like 'a meteorite fallen' I am again reminded that this body holds the deepest knowledge of another world.[21] It is not our work to make a certain sense of

this embodied knowledge, to still the energy of the mystery into studied curiosity or deep-time data. So some of us hold on, even if the numbers don't make sense. Because maybe how the obscure or the outwardly obsolete is meaningful to us *alone* is the power of what might at first appear useless; maybe we know its deeper value in connecting us to bodies, places or greater wisdoms. My grandmother spoke her London telephone exchange name down the line long past its time of use, of need or legibility. As a small child I didn't understand the code of name and numbers, but somehow knew it was a cipher for belonging.

As a project hoping to send out the sense-in-sound of Earth, the Voyager Golden Record was cast as 'a bottle into the cosmic ocean'.[22] Giggs writes about the record holding the song of humpback whales; it also carried the heartbeat and brain waves of Ann Druyan. Having recently fallen in love with Carl Sagan, the astronomer leading the team assembling the Golden Record, Druyan described the feelings as being on record 'forever'.[23] As the phone rings on into a dimension we have no ability to grasp the coordinates of, as letters are sent to the ghosts of dead poets and ancient whale song long passes, reaching, through oceans and bodies, I think of the unknown receivers – as yet to make sense or no sense – of the lover's heartbeat in space, on record, in love, forever.

Love, forever,
Ella

BLOCKED

Vibeke to Ella, Amsterdam,
28 November 2021

How I love being acoustically affiliated! The way these letters are keeping us in tune, like two instruments ongoingly harmonising without a concert to follow in mind.

The ocean I am currently facing is one of wavy sheets in my sticky sick bed, stirred only when changing sides or by my dog Maggie's paw peddling, as she runs after dream creatures.

Flu has hit hard, dissolved my appetite and taken my voice. Coughing feels like choking sometimes, like there's water in me that wants to escape.

I was recently reminded that for a good decade I had a consuming fear of drowning. Fed by news items on tsunamis across the Indian Ocean in the early 2000s as well as the blockbuster *Titanic*, which came out around that time. In my youthful experience both were evenly real, projected from a realistic-looking screen. As sometimes – mercifully – happens with fears, I gradually forgot about it. Only when I recently learned about 'dry drowning' and how, after having inhaled water, the body can still experience drowning even if on dry land, did I suddenly remember. This 'secondary drowning' can happen up to two days after leaving the water.

I'm not sure why I'm telling you this and how come it intrigues me so, but I think it's the remnant, the fatal injury, within the body of a world so uninhabitable. The same way a whale beached alive can still die from its terrestrial collapse after its body has made its way back into the buoyant ocean waters. Another take, perhaps, on the body holding the deepest knowledge of another world.

Lungs filled with water, like those of the unborn child of my sister. When touching her big pregnant belly I felt a wave; water set in motion by a kick from inside her. 'When a woman gives birth, her waters break and she pours out the child and the child runs free.'[24] Strange to think that once this child starts breathing air – like all beings with lungs – they will grow a fear of drowning.

There's so much more I wish to write to you but my mind is making funny loops, confusing my words. Before signing off this letter I do want to respond to you addressing those 'unknown receivers' in your last letter. Because we spoke of noise and how increasing underwater noise can block whale communication from any whale receiver altogether; how a receiver needs some extent of silence. I remember Will mentioning how within an ecosystem different species occupy different sound frequencies, and how a silent frequency can portray the loss of a species.[25] Do you think the future will inevitably be less silent than the present, or might silence gain ground somewhere?

Sending love, forever, Vibeke

AN ACOUSTIC FIELD, WIDENED

Ella to Vibeke
London, 13 December 2021

> The whale body never sleeps for fear of drowning, or
> not fear, but deep knowledge. A profound understand-
> ing of breath, a remembering of air as the breath that
> will sustain it.[26]

I opened your letter late in the night, the rhythm of my reading
following the gentle sleeping breathing from other rooms.
And as your words met the mood of this night and my thoughts
went out to you and your lost voice, another tuning effect took
place: my surroundings felt ever so slightly changed, a fine fre-
quency shift. I began to hear in this lulling mix of breathing
bodies the gentle rise and fall of serious and considered con-
versation. Inhalations overlapping exhalations like slow, soft
voices.

Unless we are somniloquists, in sleep we lose our voices. Or
our voices as we might recognise them. Then there are the voices
we might only find, or know, in sleep. My grandmother who
spoke old telephone codes down the receiver also spoke some-
thing sounding like Early Modern English in her sleep, and so

I have a sudden fantasy of phone lines wired to dreaming voices – where your father's stranded number is answered at night by a voice which, on waking, conceals itself.

I now think again of your writing about the different qualifications in naming whale sound as voice or song and find a lateral response in how Rebecca Giggs hears something closer to telephonic technologies: 'Minke make a noise like an old-fashioned dial tone, the ringing of a dormant signal exchange.'[27] Neat categories collapse when sound passes through them; and here, beyond the binary of voice/song, are the communicative dial tones, signals, ringing. While listening is often caught up in games of resemblances, Giggs's attention to the diversity of whale sound widens the acoustic field in which we, you and I, are working with one of the most mysterious sonic documents. I listen to the silent whale again and I can hear it as signal – a coded communication in three movements.

And this document, so difficult because *outside its own living frequency*, brings me to your last question – about the frequencies falling silent as species decline. I am thinking about who will be able to hear these frequencies disappearing and how (and with what interests), taking into account that the work of listening for what falls out of range is shared: 'In the lifeworld of connectivity, the well-being of one is enmeshed in the well-being of the others. There is no position outside of connection.'[28]

Through Deborah Bird Rose's images of wild connectivity, and your writing of the baby born from water to air, I am reminded of how we wrote of the recycling air between bodies,

61

between species, through the image of the sleepless whale and Luce Irigaray's *The Forgetting of Air*. [29] And now, writing in the night with the breathing-like-waves breaking in-ear, I think of your fear of drowning and the superstitions connecting the child born 'in the caul' with the inability to drown. Only revealed to me after my youngest child was born with the amniotic sac intact (a 'mermaid birth'), to be born *en caul* was once considered to protect not only the baby from drowning but anyone in its possession. Sailors would purchase the cauls as late as the 1950s as protective talismans before going to sea. [30]

By day and into the night, the drowning I really fear – in the Mediterranean, in the Channel – feels close. Because it is close. *There is no position outside of connection ...*

I hope you have found your voice.
I will go listening ...
... with deepest love,

Ella

LISTENING IS A PLACE
WHERE CONTENT EMERGES

Vibeke to Ella
Amsterdam, 16 January 2022

A total joy to address you on the page again!

The mermaid birth of your youngest has remained in my thoughts. How extraordinary, a postponed birth, at least from the perspective of the child, who for a brief moment remains unborn yet surrounded by the world. Within the unbroken water.

Which reminds me, did the news of that unearthed egg reach you? Within it an ancient dinosaur embryo, fossilised before it was ever born. Turned into stone those baby bones that never lost their flexibility.[31]

When did you learn that the lungs through which we breathe are nothing like balloons but are weighty organs instead? Veined flesh, not like anything you might imagine air to pass through, and yet it does, in big gulps. I was reminded of this recently when I saw a pair of latex-gloved hands lift the lungs out of a small whale and put them on a stainless steel tabletop in a necropsy room. I stood breathlessly, attentively, as I watched those same hands touching the whale's lifeless fins, in which small finger bones could still be recognised – evolutionary

leftovers from a long-ago life on land. This whale was stranded for reasons the gloved scientists were trying to find out. With every touch, with every glance and with every cut the archive of the whale body was being unlocked. No clues were found inside the whale this time, though often what they find are mirrors. In the heart of the whale, in its stomach, bloodstream and fat, are often nestled traces reflecting a human society and the objects and pollutants it produces. *There is no position outside of connection.*

Through you referencing *Wild Dog Dreaming* and me recently reading Eduardo Kohn's 'How Dogs Dream', I'm imagining how it changes the perception of dreams – as well as the dreamer – if we consider that 'dreams are not as representations of the world. Rather, they are events that take place in it.'[32]

Like many dogs, Maggie is a wild dreamer. Throughout the day she will doze off only to enter a dreamworld where running seems to be the common state. I entertain the idea of glimpsing into her dreams by the steady choreography of her sleeping paws, which appear to enact a weightless chase. She also has a dream voice, air passing through her larynx, but a sleeping mouth not shaping a more pronounced sound than a high-pitched squeak.

It's hard to resist imagining what a dog's dream might be like. Knowing that dogs have a sensitivity of senses so different from ours, their dreamworlds would likely operate on entirely different sensorial cues than ours. There is no way of knowing.

And 'If a lion could talk, we could not understand him',[33] says Ludwig Wittgenstein, his point being that our language is our way of life and it is how we see the world.

We wouldn't be able to have even the faintest grasp of what the 'silent whale' might be communicating. Yet we remain to listen, knowing that, regardless of understanding, connection is inevitable, believing perhaps in 'contact becoming content'.[34] And that listening to something or someone is a place where content emerges – listening to the ground, the city, another person. Which brings me back to the mermaid born, still attached to the placenta: that oxygen-rich interface, that shared organ, shaped around the urge for contact.

With ever more love,
Vibeke

LOVE
IN LONGHAND

Ella to Vibeke

London, 30 January 2022

So many images of the inside meet in your letter: the folded dinosaur finally born in stone, the mirrored traces in the bloodstream, the racing thoughts of the dreaming dog. And your beautiful question of the inside – from the scene of weighted whale organs – moves me back through the pages of a book on the human body, published the year I was born. When did I learn about lungs? On one of the book's bodies, drawn in blues and soft reds, a pop-out paper ribcage protected delicate approximations of a human heart and lungs. I was small and, as sometimes happens with the figures we meet on the page, the body in the book became part of my imaginative world. From the cover a single giant eye, surrounded by concentric circles of muscular tissue, would catch mine.

I could see inside the body in multidimensional detail, and in return (I imagined-reasoned) this figure of the book must be able to see inside mine. Or at least look back, with a reciprocal power of deeper seeing. We trust we know what is inside us, and each other. I can hear the heart I have never seen.

Your letter returns us to the powers of learning the world through listening; and learning as a process of sensing over the shorthand of 'making sense'. A slow kind of attention to what we find in the world, and what finds us. The longhand of making sense? I think I dwell in this space you open up at the end of your letter because I have been feeling my way in gradual response to a year-old encounter with a scene that became an image, and later a pair of images. An encounter I think of often when I read your letters and which I have not, until now, been able to put down in words.

In February 2021 I saw LOVE at the end of the road, in large letters, painted black. I could stretch my hands up into the arms of the V and fit inside – this was the scale of the word, on the pale hoarding, fencing off the old gasworks. By April the hoarding had been whitewashed, while the ghost letters of LOVE remained. I had taken a photograph of 'before' without thinking of an 'after'. I took another photograph, the spectral LOVE of 'after'.

And now I keep returning to the photographs. My making sense of these two images is slow because they remain with me while still I am finding the correspondences. As with the eye on the cover of the human body book, this is a scene giving me as much attention as I am giving it. I see LOVE in the before, and after.

'The search for love continues even in the face of great odds.' Two days after I sent my last letter, on 15 December 2021, the incomparable bell hooks died. 'The search for love...' is a graffitied

declaration she describes giving her hope in the opening to *All About Love*. Later, after she finds the artwork painted over 'with a white paint so glaringly bright it was possible to see faint traces of the original art underneath', she searches for the artist, who gives her snapshots of the work as it was, before.[35]

Now you see it, now you don't. Sleight-of-hand speech performs disappearance by naming it, while the object is always near, close at hand – inside the magician's sleeve, between her fingers. And what if we see more clearly in the 'now you don't', the now that is the after (the now *inside* the after)? When we sense what we have lost more profoundly? I look again at the image of the obscured word. Now you see LOVE.

Goodnight, more love,
Ella

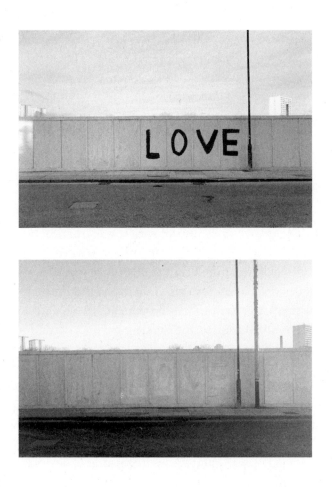

THE NOW
INSIDE THE AFTER
/
THE AFTER
INSIDE THE NOW

Vibeke to Ella

Amsterdam, 13 February 2022

I will include your encounter with the anatomical book – the eye of a young girl looking deep into the printed eye on a book cover – in an imagined collection of false-eye contact. Other opaque eyes that come to mind are those winking on the wings of butterflies or gazing lazily on the feathers of peacocks. Those eyes are not intended for looking beyond being looked at. Which is not to say that these eyes are necessarily passive, like you wrote. Isn't it Nabokov (who was himself a careful observer of butterflies) who opens *Lolita* with a scene between two young lovers, while a pair of discarded sunglasses lying in the sand are mentioned as the only eyewitness?[36]

The hard whale eye, possibly the world's most resilient eye, is designed to withstand the high pressures of deep sea. Did we speak about it in our letters, or was the whale eye part of a conversation we had elsewhere? I can't remember now. But as

much as the jiggly-ness of lungs captivated me, so did learning about the toughness of these gentle eyes.

Engrained within me is the image of a hooded man walking onto a foggy city square. It's deserted. It's black and white. Empty except for a colossal carcass, lying amid the wreckage of a crate. As if by magnetism, the man moves towards the giant's inert eye – which happens to be at eye level – and looks.[37] What does he see? What is it that migrates with the look passing from whale to human, human to whale? [38]

I'm happy you found the occasion to put your rendezvous with LOVE into words. While you mention the clear traces of its intended erasure, I'm tempted to think that the afterimage, the one still visually echoing in your mind, might have been enough to recall LOVE, over and over again. On the highway between Amsterdam and The Hague there is a viaduct, and each time I drive by I'm reminded, even if the painted lines were erased several years ago, of the words: *act as if our house is on fire. because it is.*[39]

Like blinking after the flash of a camera – or the flash of a fire – the image of the bright light remains even when shutting our eyes, bouncing back and forth against our eyelids. We literally absorb these images, they become part of us. Leaving a physiological imprint. Similar in a way to a loud bang leaving ears ringing. Like you mentioned, the now *inside* the after.

And what then about the after *inside* the now? Or rather, how to sense what is yet to come? 'Shifting attentions alters future sensations that are importantly not fully ours to behold.'

71

Profound poetry by the sonologist who suggests that listening to the expansiveness of earth-bound sound 'may provide some provisional grounding in attentions-yet-to-come'.[40]

Sending you much love, on the brink of Valentine's day.

<3
Vibeke

EYES WITHSTANDING PRESSURE,
AND EARS

Ella to Vibeke
London, 13 March 2022

Floodlights rush the football cage; red paint reads 'there are no rules'. Children raise palms to the sky as newspapers wave their broken headlines about blood and hands in the breeze. I watch these elements fuse while listening to a precious friend describe grief in a voice note, love under pressure. Her voice in-ear recasts the scene, the illuminated pitch shimmering. I sense the body she describes holding her just days before and I have no words. *Future sensations* – a train passes through the smell of petrol – *not fully ours to behold.*

I have no words, I am lost for them. How do we meet the world in writing now? I imagine if I keep asking *how*, then this world, as I am experiencing it, will show me. I am still thinking about your letter and what you describe of receivership and attention, about the eyes withstanding pressure; and what, as well as who, bears witness. I see incidental altars everywhere.

Looking out towards the south from where I live, Canary Wharf is the city in the city. The spikes in a flatland. I watch each night as the financial heart of London transforms into a new

monument, to hope. By evening the tower at its centre is flashing blue and yellow – a skyscraping lighthouse visible for miles across the city, solidarity for Ukraine beaming from the moneyed Docklands. This city is as violently contradictory as it is beautiful by night.

How full this view from my window, of Canary Wharf in the dark – a view I have never simply loved and one that always appeared to signal a future as yet unhappened. Now I learn a fault line runs under it. And another under Westminster, the home of Parliament. These traces below the great powers of the city were only recently discovered. I feel the subterranean breaks, the volatile ground. I think of the razed cities at close distance, their refugees refused entry to this small island. Blood / Hands. Let Westminster shake and with it the towering city banks flashing for peace.

The ground is moving and even memories are tectonic – faulting and folding from the pressures of the present tense. I sent my friend Flora [Pitrolo] pictures of the shaking city. One blue, one yellow. Signals in the night. [41] In London's lockdowns we sent pictures from either side of Canary Wharf – it held the midpoint between, both separating and holding us together. Now this view, so full of before-images, adjusts, as if aware of new realities. Can a view come into awareness of its affective power? Can lost sunglasses witness lovers in the 'violet shadow of red rocks'? [42]

Now Flora is in Palermo, while always outside my window, behind the view, on the dark side of what I am able to see. The

74

city holds her in it, as it holds some seismic futures, some corrupted sense of freedom, some exquisite light.

> You tell the future as you tell a story as you tell time as you tell me your name. For divination is nothing but an articulation of the future; and the future, as we know, does not exist as such, but is the shimmering cast off by the past and the present. Divination is simply the devotion to this shimmering. [43]

I will return to the whale's eye, I will return. Thank you for meeting me in writing, for guiding with the grace that is deeply and dedicatedly yours.

Love, on all frequencies, with attentions-yet-to-come,
Ella

I ADVOCATED FOR
DOODSREUTEL

Vibeke to Ella
Amsterdam, 27 March 2022

I grew up realising my uncle Rob served his country for a wrong cause.

As a young man on military duty, he was called up to fight as part of the final chapter of the Dutch colonialist occupation of Indonesia in 1947. Dutch history books for a long time called this last episode of oppression of Indonesian independence a 'political action'. Only decades later was it called for what it was, a dirty war. Uncle Rob was a pacifist, he was a soldier. He was an art historian who loved drawing the thatched roofs of barns, he carried a gun. Uncle Rob was a flamboyant homosexual, he had a crew cut. He was the brother of my grandfather, he was another's enemy.

He never spoke about it and we weren't allowed to ask.

After his death, many years later, I inherited his lifelong correspondence of letters and postcards. In 1948 he received a letter from his youngest sister. The address mentions the information of an army base in Indonesia. Of the fears and conflicts the letter mentions nothing. Instead, it describes in detail the

early crocuses appearing in the garden of their parents in yellow and in violet.

I remember the confusing blend of judgement and admiration. For it appears to be a curious superpower, to be involved with horrors while remaining tender towards newborn flowers; to protect oneself from going numb.

I love the planet because
my Mother
is in it. [44]

I listened to those words last summer while walking on the pebbles of the shingle of Orford Ness, a place for which – as you very well know – Ilya Kaminsky wrote a book of poems without ever having visited.

How deep the extent of his imagination, of the salty air, cry of gulls, the bristly thistles and the remnants of military buildings. Not to mention the ceaseless wind. Just a few metres from the shore was a large pile of bricks that used to make a lighthouse, deconstructed before it could be swallowed by the sea. Kaminsky, who writes that silence is an invention of those who – unlike himself – have hearing, puts into words a real place he visited through thought.

I'm thinking about words this morning and the *experience of having none*, of not being able to find them when in search of them. Causing this sensation that, for better or for worse, one is language-stunned, possibly a silence of sorts. I believe that

it's always better to have access to more words rather than fewer. And so, when some years ago I learned that the Dutch dictionary erases words when considered not in use anymore, I was surprised at first; later, I became worried. Not just for the possibility of any word being lost from such a linguistic guidebook but specifically for those words describing death. As it seemed it was precisely those words causing discomfort that increasingly were being shied away from, resulting in their elimination from the dictionary. I was in contact with the publisher of the dictionary to enquire what exactly makes linguists decide the livelihood of a word, and I was told that this is defined by the frequency of a word being printed in the public realm, such as in a newspaper. (Imagine the extent to which journalists define our vocabulary!)

For the last few years I've been making the effort to reanimate one of those erased words. I advocated for *doodsreutel* (death rattle) by writing an obituary advertisement in a Dutch national newspaper for the word.[45] After that, I urged many journalists, but also novelists and poets, to publish the word, to animate it. This wasn't because I don't experience discomfort with the word, because I do, but because I believe we also need words to describe the horrors, that which we fear. When it comes to something as complex as death, I feel we need all the words we can find; we can't afford to lose them.

I'm thinking about words this morning because I learned that *doodsreutel* has again been included in the newest printing of the dictionary.

Buon viaggio, you are on your way to Palermo!

Sending love *in devotion of the shimmering,*

Vibeke

THE WIND

Ella to Vibeke,
London, 11 April 2022

Language-stunned – I love how you name the sensation of having no words. I am now thinking of the crocuses described to your uncle from a distance by his sister, as I look out at the same flashing tower, a month on. I am thinking of the letters you were gifted and of you reading them, feeling the temperature of a garden written into healing correspondence. My grandmother often wrote about what was happening to the tree outside her window in letters signed with our shared initials. I spent so much of my childhood in her garden, inside the deep walls of ivy, with the damsons and The Doctor – a pink tea rose she picked huge flowers from, in the rain, the day I was born.

The day I left Palermo, Flora and I walked through the botanical gardens looking for the lunar lemon. She told me lemon shares its word root with light and moon – I am thinking of you calling for more words and sensing, in the garden, how languages grow ...

Into this movement of memories as I write them, you send me a picture of the whale jaw replica in your studio. Are you the shaded figure looking at it, holding your hand out as if

counting the parts? Strange for me to bring the image to the letter and switch channels, but then this has always been the way, moving our thoughts around and between the places where they might have some space to land. Maybe I also bring the scene of your studio here because since I last wrote I have been living in the meshwork of precious conversations, with friends at distance. You and I have spoken of this before, of all the ways the circles meet. And while together in words with loved ones, I also sometimes catch sight of them in the margins of an image they send: the edge or shadow of a hand, a reflection or silhouette of a body as an incidental aside.

I have not seen you in so long now, and while these letters speak often of how we sense each other, I think of the intensity of closeness, the reciprocal power, in being eye to eye. I return to the single whale eye looking out, as you describe, through the scene in the foggy city square. This time, having found some words, and full of the story of your uncle's letters, I see the subtleties of this meeting of eyes – as a meeting between planes, between the living gaze and the dead's lashless eye:

> Far back on the side of the head, and low down, near
> the angle of either whale's jaw, if you narrowly search,
> you will at last see a lashless eye. [46]

This description, in *Moby-Dick*, of the narrow search for the eye – to seek out the seeing part of the lifeless whale – is a strange communion between the hunter and its kill. This is a different

kind of intensity from the eyes alive and locking. To meet the dead eye, large enough to fill your hand. It strikes me again how much these letters attend to the afterlives of these giant creatures; how unusual to meet the whale in life, and in death.

I think of the whale in the museum again, the skeleton hanging in the stilled animation of its descent for food. I see Hope diving to the floor of the great hall, the ground giving way to submersion. Have you ever experienced a floor revealing another dimension, another plane? Last month I was invited to the Cosmic House, designed by Charles Jencks and lived in by his wife Maggie Keswick Jencks and their young family from the early 1980s.[47] It has its own architectural cosmology: to walk around the house is to follow the rotation of the earth around the sun, moving through day and night and the changing seasons. I felt many things. Some parts of the day play back like dreams in impossible architectures, as when I stood at the edge of a black hole – a darkly jewelled, perfect circle; a pool for falling into. I had walked down the central spiral Solar Stair of the house and landed at the event horizon of Eduardo Paolozzi's mosaic abstraction of a black hole. A plaque like the large and complex pupil of a giant's eye.

Sublime gesture to lose oneself in eyes of all kinds, to get lost in the voices of people we love. I open and listen to a voice note from our friend Angeliki [Tzortakaki]; so much of her voice is lost in the storm on the Deserta Grande, I am left with words caught from the whipped wind: *I'm sitting on the black volcanic rocks ... dark grey ... dark red ... black ... I'm looking at the sea ... with my*

left hand ... the Mediterranean sea ... a nest ... closer to me. ...boiling lava ... the weather ... the sun is a bit shy ... goes for a few hours ... on the way we could see a storm ... grey vertical ... light ... the island has this ... pushing up the ground ... mountains ... I wish ...[48]

I wish I could hear inside the weather, mend Angeliki's broken record in my receivership of her note. I wish this as much as I love how I can hear the wind refusing her one position in time and space. We are about to leave London to scatter ashes on Helvellyn, a mountain in the Lake District. I am thinking about what we ask the wind to disperse, so that we can, through releasing, remember. I am thinking of Angeliki's words carried away, now hovering in different parts of the island, skimming the rocks, out on salt water ...

> Is it not curious, that so vast a being as the whale should see the world through so small an eye, and hear the thunder through an ear which is smaller than a hare's? But if his eyes were broad as the lens of Herschel's great telescope; and his ears capacious as the porches of cathedrals; would that make him any longer of sight, or sharper of hearing? Not at all. – Why then do you try to 'enlarge' your mind? Subtilize it.[49]

I'm looking at the sea ... with my left hand.
With much love,
Ella

A WHALE THE SIZE OF A CELL PHONE SCREEN (WHERE WOULD YOUR KEYS BE?)

Vibeke to Ella
Amsterdam, 1 May 2022

The fragmented body, channelled through the ashes and Melville notes mentioned in your last letter, reminded me of when I first witnessed a whale stranding, near Scheveningen in 2015. I was working at a bakery that morning when the news reached me: a floating humpback, dead for some days, probably a collision with a ship. Between batches of baguettes, I impatiently tracked the updates on how the carcass was followed along the surf, guided ashore, where the research teams arrived. As soon as I finished my early shift I headed to the coast in search of the whale. It was by smell that I encountered it first, a giant smell, sweet and rotten like nothing else. I had been so curious to see the body of the whale and measure it by my own body. But when I reached the site, the whale was nowhere to be seen; in its place stood a huge yellow container, and a second one some 100 metres further. A person guarding the container, equally dressed in yellow, held me back from climbing up the container to look inside. Instead, he suggested, I could lift my phone above my head and, with my arm stretched out as far

as I could, direct the camera inside the container. I didn't even own a smartphone at the time – it was the tiny eye of a Motorola flip phone that gave me my first glimpse at a whale body, the size of the cell phone screen.

The scale of an eye and the seen subject can be so widely other that it can feel strangely puzzling how one fits through the other, even by reflection. I'm trying to remember who wrote so beautifully about the water seeing itself reflected in the eyes of Narcissus.[50] The only hint I have is that I read it at a time when I was less consistent with making notes. Before becoming so humbly aware of my own forgetfulness.

My father always puts his keys next to the thing he wants to remember. Obviously, this isn't a waterproof solution for many memorable subjects, but since the things my father wishes to remember are often food-related I will occasionally find his keys in the fridge.

Where would your keys be? Beneath the rose tree in your grandmother's garden, next to pink cabin light, beside lemons, on the moon? A while ago you sent me Frances Yates's wondrously detailed description of ancient memory techniques, following the example of the 'memory palace', whereby an entire architecture is constructed to locate a memory. Such a space 'must not be too brightly lighted for then the images placed on them will glitter and dazzle; nor must they be too dark or the shadows will obscure the images'.[51] Nothing however was mentioned about the temperature of a memory, so the fridge might be a perfectly fine place after all.

Funny, I suddenly realise I'm responding not to your letter to me but to another text you recently wrote, which was echoing in your last letter! On notes on paper and on your own skin. Loosely in line with what you described regarding us 'moving our thoughts around and between the places where they might have some space to land.'[52]

Fragmented will be how most people experience – if ever – the whale body. Possibly partitioned as food or processed as medicine or soap, oil, cement or electricity. Even when alive, when the whale body is whole, it will likely surface from the ocean bit by bit, presenting just one part of the whale to the human eye at a time.

Did we speak about the parable of the blind men and the elephant?[53] Do you know it? It has been much on my mind in relation to a film I'm making. The parable describes a group of blind men who for the first time encounter an elephant. As their hands land on the elephant, they exchange experiences. One, touching the trunk, describes how *it's very much like a snake*; another, tracing the elephant's hind leg, describes how *it's very much like a tree*. Each man experiences a different fragment and from that assumes another body.

My mind wanders to the characteristics a lemon and the moon share; a bright and light-reflecting surface, a pockmarked skin, a word root. Maybe the moon is also like a whale, only revealing part of its body to our eyes at the time.

In an attempt to reach beyond what Oscar jokingly calls *duty-free English* – the at times poetic but more often compact

87

and clunky vocabulary that is shared in many international artistic communities, where most members have other mother tongues – I read Merriam-Webster's 'Word of the Day' newsletter. Today it brings me a familiar word that effortlessly coincides with our writing: Leviathan, luh-VYE-uh-thun (*noun*), something large or formidable.

Sending (something very much like) love,
Vibeke

THE INFRASONIC WHALE VOICE
HAS ALWAYS BEEN STRANGE
IN TERMS OF SCALE

Ella to Vibeke

London, 9 May 2022

We first met surrounded by books and shards of bright January light. I remember how you sensitively rearranged the space with your words, telling me the story of your listening, through the scent of baking bread, to unfolding reports of a whale stranding. Your heading to the coast to find the whale seemed inevitable, one among many beginnings. We were in the library of the Delfina Foundation, and I had introduced myself by interpreting events up to our point of meeting through their swerving emotional range. You smiled and said something like, 'Ah, so you've been laughing, and crying ... I wonder what I am going to make you feel?'

Last night I thought of all that you have made me feel, beginning with this scene at the bakery brought into the bright light of the library. And as I sat in a large and familiar theatre, the air thick with sweet charcoal smoke, I thought about the encounter with acoustic information through a medium that carries so much other sensory material in the mix: how we listen

out through air with a full affective range. The air of the auditorium must be richly weighted with particulate matter turning to dust, remains of all that has filled and left the stage, remains of all who have gathered together evening after evening, diffused, dispersed.

In an earlier letter I wondered similarly at what might hover in the populated air of the Natural History Museum as a zoo of ancient matter. I asked my friend Ben Elliott, who was working in the museum archives recently, what they smell like. 'They smell like a pet shop,' he said. 'A dead pet shop?' I asked, and when he answered: 'An alive pet shop!' I was immediately there, among the captive animals of the research collections. The living dead, their endings and their lingering sensorial traces, like leather, like sawdust...54

You encountered the giant smell of the whale before you met it with any other sense. You had wanted to understand something of the size of your body in relation, and yet you could feel the size of this creature through scent alone. How to measure a body against the odorous air? It is a wonderful memory for so many reasons, among them how it moves through ever shifting perceptions of scale. The whale is as big as the yellow container, as small as the flip-phone screen. The whale is the size of its smell.

The infrasonic whale voice, the drone constant through these letters, has always been strange in terms of scale. As the frequency shifts to bring the recording into audibility, so does the size of the body we hear moving its energy through water. I

realise, as we write towards the last of our letters, how the silent whale becomes ever more obscure. We search for ways of saying what *it's very much like*. Since first meeting, we have often talked about our favourite measurements of scale made by comparison; those kinds of pop correspondences between things, to bring into human relation more mysterious or unknown objects. A whale heart, the size of a small car, the size of an undetected asteroid.[55] I wonder now what kinds of non-technical comparison might be made with the silent whale – sound as big, as deep, as long as …

I am thinking back over our many conversations and about the scene of our first meeting because I am thinking of endings. Astrida [Neimanis] sent a corresponding text, gifted to us as the thinking-through-writing she was doing 'in the background' while we have been writing to each other. In 'A Gut Feeling' she gestures towards her research on endlings, the last known animal of a species. I stay with the word endling a long while, a name giving a body to the end.[56] And also with its diminutive -ling suffix offering some sentiment, some scale, for the strange and sorrowful condition of ending a lineage, ending a line.[57]

How do we end? With what feeling, thought, and attuned sense? What do we want to leave? What can we not help but leave? You once told me of the deep channel through which whale song can travel without the energy of the sound wave dissipating. In the 1940s, geophysicist and oceanographer Maurice Ewing theorised such a sound channel would similarly exist in the upper atmosphere, and as part of Project Mogul

sent large meteorological balloons carrying microphones and radio transmitters into the skies to detect long-distance sound waves from Soviet atomic bomb tests. Project Mogul was a forerunner of another espionage balloon project: Moby Dick, the subject of the silver image accompanying our letters on Ocean Archive. When we began writing to each other we were stunned by the world, and now more than ever. How to end, when what we offer each other keeps finding new and ever deeper points of correspondence? When new channels are found? When we keep making each other feel, and want to hear how and why; when we remind each other where to find the keys ...

With much love,
Ella

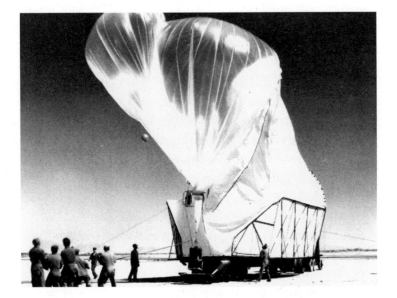

A VOICE LIKE TONNES OF ENERGY
(AND HOW INCREDIBLE
YOUR HAIR SMELLED!)

Vibeke to Ella
Budapest, 28 August 2022

On the terrace from which I'm writing to you it's sticky hot, even in the shadow. Lemonade is served in tall beer glasses on which droplets stick to the outside as if they have triumphantly found the pores in solid glass. Meanwhile, the mesh of the seats is gradually marking its memory in the thighs of the lemonade-sipping, chain-smoking and newspaper-scanning crowd. I wish you were here.

This summer's drought, and all that it brought to the surface, made me think of you. Shipwrecks, ancient astronomical clocks, dinosaur tracks, bodies of all sizes: these had always been there, only now uncovered for us to behold. A presence laid bare, like a sound (or silence) that is suddenly revealed when other frequencies fall out. Displayed on riverbeds around the world, the drought recalled many ghosts: 'remains of all that has filled and left the stage, remains of all who have gathered together evening after evening, diffused, dispersed'. The whale voice, like other infra-voices, is no ghost of course, it is indeed

94

very much alive and embodied, like you and me. A voice like tonnes of energy sent into the world – what could be more animated than that? Whales unveil the world by putting energy into their environment. Most of our senses are finely tuned to picking up stimuli that already exist in the wider world, which contrasts with an echolocating whale, who 'creates the stimulus that it later detects. Echolocation is a way of tricking your surroundings into revealing themselves.'[58]

Something I learned about silence is how I longed for it. Which is why I'm writing only now, towards the end of summer, following some much-needed time offline and, amazingly, after having seen you for the first time since the start of our correspondence in early 2020! Just before and briefly after seeing you I scribbled down some lines in which I mentioned the fragment above, which I had recently read in *The Atlantic* (the irony doesn't escape me). I reflected: *Soon I will click and you will bounce back to me!* And what a joy it was to be in one space again, to bounce back to each other, and how incredible your hair smelled!

Writing that down makes me realise how romantic it sounds to describe someone's hair smell, and yet that is the sensual dimension that was drained from our contact in the time between this and our previous meeting in person. In those two years on screen, how could I have possibly picked up that piece of intimate information – that you are someone who enjoys quality shampoo!

On quite another note, did you know a helicopter rotary blade can be used to construct a speaker to transduce infrasound?

Propagating the air into shockwaves that could be throbbing the message: *I am whale, somehow.* Bouncing against every wall.

Was it simply that I was looking into DIY speakers while I was surrounded by Spanish-language natives, or is the synchroicity of helicoptervoice and *tocayo* deeper than that? I conveniently suspect it is. *Tocayo* is a Spanish term referring to someone who goes by the same name as you. Which feels like a measure of some sort. Is there anything in this world that would address 'silent whale' with the word *tocayo*, I wonder? Somehow it appears to me that that is what you bring up by questioning 'what kinds of non-technical comparison might be made with the silent whale – sound as big, as deep, as long as …'.

And I think that may be a question sinuously moving throughout our entire correspondence, where the frequency of the silent whale became the bandwidth through which we imagined, explored and resonated the world as it changed (around) us. This is the last letter I'll write to you. Soon we will bring this whale to rest, at least the silent whale inside of us. On what frequency might we meet next?

You speak of endlings, of endings, and it makes me realise that this, in part, also kept me from writing: the knowledge that the thoughts I'm arranging easily gain the weight of consolidation or conclusion, even when both of us know that new channels have been formed, like you said.

Let me then recall Ken Liu's story of the 'Quatzoli', whose brains are made of porous stones in which thoughts are manifested as the mineralised channels opened up by little streams

of water. When channels are blocked, flows can no longer enter and memories are lost; however, when new channels are created, previously separated flows occur: an epiphany.[59]

I will miss writing to you in this way, even when I'm filled with curiosity as to those new channels of thought we will continue to encounter, even if they turn out to be old channels, revealed again by the drought.

With Love
ever more ~

Vibeke

THIS WHALE / NOBODY'S WHALE / BUT REST

Ella to Vibeke,
London, 17 January 2023

It is midnight, time feels precious – and it always does, but tonight I will finish our letters with this letter, a letter held by the soft edges of the night, by the edges of many nights, because a letter with so many beginnings I have let fall away by morning. These beginnings which could never quite lead me to the middle that would lead me to the end, as if I thought I could plan how these last words now land or know the shape of how I leave things. Throughout these years of writing to you I have always let the letters lead me, let the rush of writing draw in the stories and thoughts, the dreams and desires in the moment of composing.

So why now have I taken too long to write this, to finish? Maybe our continuing conversations taking place on other channels has enabled a kind of suspension of this last letter. I say 'maybe' because this aspect of our meeting and talking elsewhere does not fully describe why the writing is in waiting – I realise I am hesitant to bring this correspondence to completion, to write the last words of what has always felt so alive to the continuous, *to bring this whale to rest*. In many ways the

letter I wrote last to you held the sense of an ending more light-ly. Is it always easier to write about the end when it hasn't yet been reached, when it is still a kind of fantasy? I wrote to you about the *endling*, and so if that was the letter as endling – the last in a line of letters – this must begin the letters' afterlife, or at least speak to the open and unknowable conditions of an afterlife, which then is also a kind of otherlife, a spectral future. No end in sight, no end in listening.

Remember how I once described Hope, the suspended whale skeleton in the hall of the Natural History Museum here in London? Before writing this last letter I visited Richard Sabin, the museum's principle curator of mammals, responsible for the installation of this whale, which he refers to by its official registration number: NHMUK ZD.1892.3.1.1. As he called this skeleton by its number, I realised with sharpened focus how weighted the naming of these remains is – how naming takes charge and ownership of a body, gives the body a context or a charm, sometimes both, and a position in the human world of relations. This body that was never meant to be owned. When I first thought of Hope and brought her into these letters, I called her by a name I didn't question the origins of; I didn't think of who had named her and why. And when did the blue whale recording at the heart of these letters become *silent whale?* Deep in the museum's outstation, as I was thinking these thoughts to myself, Richard simply said, 'nobody's whale'. He did not name her Hope. His caretaking of wild remains comes from a deep and particular respect for the unhaveable, the unknowable,

these bodies resisting bondage in life and in death. Nobody's whales: he is surrounded by rows upon rows of whale vertebrae, still seeping ink-black oil and thin, shining liquid; by skulls pointing up towards the sky that is a ceiling, into and through the sweet scented air.

The profound sensorial effects of that first day among the whale bones will never leave me; the after-effects are stronger still. I have been thinking ever since of the whale remains that still produce, their dark oil making the bones appear burned, the oil turning the surface to a material resembling charred wood. These are dynamic specimens, they are changing, they are, in some ways, alive in their continued production of fluid. When I held a whale ear bone, the tympanic bulla, in both hands and asked why – like the blue whale skull it belonged to – this was painted black, Richard described the practice of painting skulls towards their exhibition for Victorian audiences: so as not to offend them with the explicit condition of bare bone, in how it was too close to death, too close to life. The ear bone was so heavy, a weighted shell. My hands were still full of the memory of this object when, urged by Richard, I reached inside the last whale skull to be pulled from the South Kensington whale pits and touched the soil held in the brain case since 1939. We are always too close.

I have been longing to tell you what I have experienced since last writing, having been close enough to touch so much of what has existed only in writing to this point. I have wondered at the impossibility of this last letter holding everything I want

to say. I know some things will have to carry silently in-between the lines – and haven't we learned how to do this kind of call and response over the past three years, through the 'bandwidth', as you call it, of the silent whale that holds to its mystery, its aspects unknown or incomplete? The most extraordinary and moving part of my visit to the whale collections in some ways speaks to what communicates most powerfully beyond words. Opening a door in a long row of cupboards, Richard brought out two baleen whale earwax plugs, resting like a pair of honey-coloured candles in a black lined box. Each earplug held fine and successive rings, most light and some much darker – 'lipid and keratin-based semiannual bands of alternating dark and light laminae (growth layer groups) formed over the life span of the animal'.[60] Richard explained that while these bands can be used as a proxy for calculating ageing, they also expose, in the darker rings or laminae, where the whale has produced the stress hormone cortisol. In other words, these earplugs chart the history of human stressors on whales, with the dark rings of increased cortisol shown to correspond not only with periods of aggressive whaling but with 'wartime activities (e.g. under-water detonation of ordinance, naval battles including ships, planes, and submarines)'.[61] The whale ear holds its history in relation to our own. I was moved beyond words – shaken by the markers of more than acoustic devastation – and still am.

Our writing has always leaned into its receivership as open to what isn't expressed as much as what is. We are often moved beyond words. And now it is deeper in the night, where I often

go to find the words I have lost to the day, as if the night can move me towards them again. I wonder if you know how often I have written to you in the night.

'When I thought of her it was always night.' These are the first lines the character V speaks in Samuel Beckett's ... *but the clouds* ..., his 1976 play for television, in which V is the voice of M – a man sitting on an invisible stool, bowed over an invisible table. When I stretched my arms into the large V of LOVE, in February last year, I thought of you as Voice, Beckett's V who moves through his writing, through *Footfalls* (as 'Woman's voice'), *Ghost Trio* (as 'Female voice'), *Rockaby* (as 'Her recorded voice'). I thought of you as the voice I hear through these letters, and within the frequency of the silent whale. An apparition, V exists without body, and yet that urging of the voice – by turns marvellous and terrible – to presence the form of the spectral speaker allows us to enter into a relationship of the afterlife or otherlife of a body. An embodied apparition; *no ghost*, as you write. This is the ambivalence we have had to hold in our correspondence alive and present-absent to each other all along, while dreaming of strange wonders of the living dead, the still seeping whale bones, wet to touch; the heavy, vibratory call of the silent whale that moves through our own bodies and moves us to write ...

The call of the silent whale – as afterlife or otherlife of a body – sounds the archive as no simple resting place. I think of whalefall, the large body disappearing more deeply, descending out of human range. *Nobody's Whale*. What if the archive too

opens the space for whalefall? A space contingent to the impossibility of ownership or control of the wild body? We know by now the archive has its depths, where what it holds falls out of sensorial range and disperses into others. And we know the limits to our knowing even as we hold what we hope to hear, tenderly and close enough to touch. There are many ends to the end, this is only one: a call, to you, before this channel closes.

I am whale, somehow.

Love,
Ella

1 Andrew Kötting, dir., *The Whalebone Box*, 2019.

2 Ella Finer, 'Far Stretch: Listening to Sound Happening', in *The Creative Critic: Writing as/about Practice*, ed. Katja Hilevaara and Emily Orley (London: Routledge, 2018), p.134.

3 Dylan Thomas, *Under Milk Wood* [1954] (London: Penguin, 2000), p.2.

4 Karen McVeigh, 'Silence is golden for whales as lockdown reduces ocean noise', *The Guardian*, 27 April 2020.

5 Jem Finer, *Starfield (Longplayer for Stars)*, 2019. A composition for an orchestra of stars. For more information see www.longplayer.org/events/shortplayer.

6 'Blow on your hand: it's how it feels underwater to feel the sounds on your skin, on your body.' Jana Winderen quoted in Emma McCormick Goodhart, 'Underwater (Un)Sound', *e-flux Architecture*, www.e-flux.com/architecture/oceans/341778/underwater-un-sound, August 2020.

7 Virginia Woolf, *The Waves* [1931] (London: Vintage, 2016).

8 Marina Tsvetaeva, 'from WIRES' [1923], in *Bride of Ice: New Selected Poems*, trans. Elaine Feinstein (London: Carcanet, 2009).

9 Alexis Pauline Gumbs, *DUB, finding ceremony* (Durham: Duke University Press, 2019), p.20.

10 Ella Finer and Vibeke Mascini, 'Het Hart in Haar Mond', *Infrasonica*, www.infrasonica.org/en/infrasonica/het-hart-in-haar-mond-en, December 2020.

11 Robin Wall Kimmerer, 'Learning the Grammar of Animacy', in *Braiding Sweetgrass: Indigenous Wisdom, Scientific Knowledge, and the Teachings of Plants* (Minneapolis, MN: Milkweed Editions, 2013), p.53.

12 Rebecca Giggs, *Fathoms: The World in the Whale* (New York: Simon & Schuster, 2020), p.171.

13 Janet Malcolm, *The Silent Woman: Sylvia Plath and Ted Hughes* (London: Granta, 2012).

14 Sylvia Plath, 'Burning the Letters' [13 August 1962], in *The Collected Poems*, ed. Ted Hughes (New York: Harper, 1981), p.204.

15 Clara Rockmore, archive footage in *Sisters with Transistors*, dir. Lisa Rovner, 2020.

16 Pauline Oliveros quoted in Tobias Fischer, 'Freedom through Music: Scenes from the Personal History of Improviser, Composer and Deep Listener Pauline Oliveros', *White Fungus*, www.whitefungus.com/pauline-oliveros-freedom-through-music, accessed 7 April 2023.

17 'Raviv Ganchrow, In the Company of Long Waves', lecture at SONIC ACTS Festival, Amsterdam,

1 March 2015, www.youtube.com/
watch?v=Es0y2MJoxlw, uploaded
28 June 2017.

18 Eduardo Navarro and BaRiya
(Pratyush Pushkar and Riya Raagini),
Octo-Durga, www.stage.tba21.org/
detail/research-cluster-octo-durga,
27 November 2020. The auditory
confluence of the Pacific and Atlantic
was described to me (Ella) during a
conversation with BaRiya as part of
As If Radio, Glasgow, 12 November
2021.

19 Navarro and BaRiya's hybrid figure
Octo Durga is described as 'a post big-
bang underwater cephalopod dancer
from the depths of one of Jupiter's
moon [*sic*], from Europa's oceans.
A photo-sonic manifestation of an
indigenous ancient-Indian goddess
like Maha-Durga – one of the
initiators of a primary multiverse.'
See Eduardo Navarro and BaRiya
(Pratyush Pushkar and Riya
Raagini), 'Non Local: Octo-Durga's
birth in Europa's oceans',
www.stage.tba21.org/detail/non-
local-octo-durgas-birth-in-europas-
oceans, 23 November 2020.

20 Jack Spicer, *After Lorca* [1957] (New
York: NYRB, 2021). As sent to Ella
by James Wilkes, 13 November 2021.

21 Giggs, *Fathoms*, p.318.

22 Carl Sagan quoted ibid., p.178.

23 'My feelings as a 27 year old woman,

madly fallen in love, they're on that
record ... It's forever. It'll be true 100
million years from now. For me
Voyager is a kind of joy so powerful,
it robs you of your fear of death.'
Ann Druyan quoted in 'Voyager, The
Love Story', https://science.nasa.gov/
science-news/science-at-nasa/2011/
28apr_voyager2, accessed 28 April
2011.

24 Jeanette Winterson, *Sexing the Cherry*
(New York: Atlantic Monthly Press,
1990), p.4.

25 Will Prentice, sound archivist; on
species-specific frequencies, see
'Longplayer Assembly: Will Prentice
with Vibkene Mascini (2020)',
conversation as part of *Longplayer
Assembly*, Artangel, London, 26
September 2020, www.youtube.com/
watch?v=DRbA1tJ9ozo, uploaded
14 December 2020.

26 Finer and Mascini, 'Het Hart in Haar
Mond'.

27 Giggs, *Fathoms*, p.180.

28 Deborah Bird Rose, *Wild Dog Dreaming:
Love and Extinction* (Charlottesville, VA:
University of Virginia Press, 2011), p.27.

29 Finer and Mascini, 'Het Hart in Haar
Mond'. Luce Irigaray, *The Forgetting
of Air: In Martin Heidegger* (London:
Athlone, 1999).

30 Imogen Crawford-Mowday, 'Caul:
A Sailor's Charm', *England: The
Other Within: Analysing the English*

Collections at the Pitt Rivers Museum, http://england.prm.ox.ac.uk/englishness-sailors-charm.html, accessed 7 April 2023.

31 Maya Wei-Haas, 'See a rare baby dinosaur curled up in its fossilized egg', *National Geographic*, www.nationalgeographic.com/science/article/rare-baby-dinosaur-found-curled-in-its-fossilized-egg, 21 December 2021.

32 Eduardo Kohn, 'How Dogs Dream: Amazonian Natures and the Politics of Transspecies Engagement', *American Ethnologist*, vol. 34, no. 1 (February 2007), p.12.

33 Ludwig Wittgenstein, *Philosophical Investigations*, trans. G.E.M. Anscombe [1953] (Oxford: Basil Blackwell, 1986), p.225.

34 Timothy Morton, *Dark Ecology: For a Logic of Future Coexistence* (New York: Columbia University Press, 2016), p.11.

35 bell hooks, *All About Love: New Visions* (New York: HarperCollins, 2000), p.xvi.

36 Vladimir Nabokov, *Lolita* (London: Penguin Books, 2000), p.13.

37 Béla Tarr and Ágnes Hranitzky, dirs., *Werckmeister Harmonies*, 2000.

38 Giggs, *Fathoms*, p.161.

39 Greta Thunberg, address at the World Economic Forum, Davos, 2019.

40 Raviv Ganchrow, 'Earth-Bound Sound: Oscillations of Hearing, Ocean and Air', *Theory and Event*, vol. 24, no. 1 (January 2021), p.108.

41 See Ella Finer and Flora Pitrolo, 'London–Mars–Palermo', as part of *Wind Study*, 1 May 2021, http://streams.soundtent.org/2021/projects/wind-study, accessed 7 April 2023.

42 Nabokov, *Lolita*, p.13: 'the violet shadow of some red rocks forming a cave'.

43 Johanna Hedva, 'How To Tell When You're Gonna Die: Astrology for Writers', *Solitude Journal*, no. 2: *On the Occult and the Supernatural* (March 2021), www.akademie-solitude.de/de/project/online-publications/on-the-occult-and-the-supernatural.

44 Ilya Kaminsky, 'After her Funeral, I Became an Environmentalist', in *I See a Silence* (London: Artangel, 2021), p.19.

45 For more information on this artwork, visit https://vibekemascini.com/doodsreutel.

46 Herman Melville, *Moby-Dick, or The Whale* [1851] (London: Wordsworth Classics, 2002), p.274.

47 I (Ella) was invited to the Cosmic House on 22 March 2022, by artist-in-residence Marysia Lewandowska, to think collectively about voicing the archive, as she developed her project responding to the work of Maggie Keswick Jencks. See www.jencksfoundation.org.

48 Angeliki Tzortzakaki, voice note sent with coordinates 32°37′58.1″N 16°37′42.6″W (and strong gusts) on 8 April 2022.

49 Melville, *Moby-Dick*, p. 275.

50 I (Vibeke) believe the fragment was included by Mark Pendergrast, *Mirror Mirror: A History of the Human Love Affair with Reflection* (New York: Basic Books, 2003).

51 Frances Yates, 'The Three Latin Sources for the Classical Art of Memory', in *Selected Works*, vol. III: *The Art of Memory* (London: Routledge, 1966), ch.1 p.8.

52 Ella Finer, *Pangs, the softer distance (with pink noise)*, early draft of a work in progress, sent to Vibeke by Ella in private correspondence.

53 Thought to be an ancient Indian parable, 'The Blind Men and the Elephant' is known in different iterations across the Indian subcontinent.

54 'It smells like a pet shop! Kind of dessicated and dry because of the humidity control, but with these sawdust/leathery smells mixed in.' Dr Ben Elliott, archaeologist and early prehistorian, conversation with the author (Ella), April – May 2022.

55 Tariq Malik, 'An asteroid the size of a car just zipped by Earth in close flyby', *Space.com*, www.space.com/car-size-asteroid-2020-oy4-earth-flyby.html, accessed 28 July 2020.

56 Astrida Neimanis, 'A Gut Feeling', micro-essay in response to the *Silent Whale Letters*, published on *Ocean-Archive.org*, https://ocean-archive.org/story/silent-whale-letters, accessed 28 March 2022.

57 Michelle Nijhuis, 'What Do You Call the Last of a Species?' *The New Yorker*, www.newyorker.com/tech/annals-of-technology/what-do-you-call-the-last-of-a-species, accessed 2 March 2017.

58 Ed Yong, 'How Animals Perceive the World', *The Atlantic* (July – August 2022), www.theatlantic.com/magazine/archive/2022/07/light-noise-pollution-animal-sensory-impact/638446, accessed 13 June 2022.

59 Ken Liu, 'The Bookmaking Habits of Select Species', in *The Paper Menagerie and Other Stories* (London: Head of Zeus, 2016), pp.1–9 (p.4).

60 Stephen J. Trumble et al., 'Baleen Whale Cortisol Levels Reveal a Physiological Response to 20th Century Whaling', *Nature Communications*, no. 9 (2018), 4587, https://doi.org/10.1038/s41467-018-07044-w.

61 Ibid.

Living in the Meshwork
(Of These Precious Conversations)

KATE BRIGGS

O yes – the first letter in this collection is not a beginning but a response. O yes – Vibeke Mascini opens her writing by responding to something Ella Finer must have said. Or, more likely, something she wrote. The first letter is already a second letter. What was it that Ella set down, prompting Vibeke to answer in this key of affirmation? It's possible to make out the shape, if not the detail, of it from the manner of Vibeke's responding: something has recently changed (her whole life, along with everyone else's). The change is operating on time, and the capacity to move in space. Vibeke's letter is dated 14 April 2020: it's the start of the pandemic. She is registering what Ella must have shared with her and is moving with it, associating her thoughts. Now her letter touches on something else. Again, the reference is to something already initiated. Something previously spoken of between the two of them, along with unknown others, possibly a long time ago. Vibeke writes: it 'still occupies my thoughts'. She means what these letters call, in shorthand, 'silent whale'. From Vibeke's response to a letter from Ella that we cannot read,

111

we learn that Ella has been having whale-thoughts, too. Large-scale thoughts. Deep-sea thoughts. Low-frequency, inaudible, possibly inexpressible and yet resonant and felt, long-distant thoughts. They have both encountered it. 'Silent whale' is a place-holder for a recording of the sound a whale makes, or doesn't straightforwardly make, its singular manner of communication, what is sometimes called its 'song'. It is a sonic document held in the British Library. Both Vibeke and Ella have listened to it. But – listened to it? Is 'listen' the right verb? No, for the recording is silent. The only way of making it audible (to the human ear, at least) is to speed it up, meddling with its frequencies, fundamentally altering the nature of what Vibeke and Ella would like, if possible, to hear. Imagined it?

This remarkable sequence of letters begins with a yes. It pulses with the energy of affirmation: yes to shared fascinations; yes, from two very different practitioners, to a profound interest in each other's life and work. Yes to friendship, and to love, to the work of collaboration, and to correspondence for the sake of corresponding; yes to reaching out towards each other, and then reaching further, towards the world of other people's work, their sounds and very different forms of experience, and marking this reach in writing, in an ongoing effort of recording, through joys and exhaustions, over the course of an exceptional three years. In Letter 21, Vibeke notes in retrospect that 'the frequency of the silent whale became the bandwidth through which we imagined, explored and resonated the world as it changed (around) us'.

Yes, but also no. If there is cause for letter-writing, it is generally absence. The conditions of apartness. Likewise, the whale that first occasioned this exchange, the one whose silence was once recorded: it's nowhere. How to deal with non-presence? How to honour it while actively exploring the alternative forms of understanding that negation makes possible? Like the paper cup in an empty cellar described in Letter 5, an installation by Vibeke that is a material investigation into 'the right conditions' under which it might be possible 'to sense the whale's message'. Not by way of the ear, or the eye, but 'on our skin and in our guts'.

Yes, but with spaces deliberately left, hollowed or opened out for a counter-response: a different order of yes, or a form of no. Yeses and nos called forth in a relation of active, countering, ongoing response. A situation produced by an attitude of what Mikhail Bakhtin called 'active responsivity'.[1] Vibeke may have been the first to write a letter in this long chain of published correspondence, but – to insist on this again – she was already a respond*ent*. Likewise, Ella. Her letter of reply is dated ten days later than Vibeke's. But it is not the immediacy of her response

1 Mikhail Bakhtin, *Speech Genres and Other Late Essays*, trans. Vern W. McGee (Austin, TX: University of Texas Press, 1986), p.68. The quotations from Bakhtin's work are drawn from the essay titled 'Between Affects: Improvised Dialogism and Collective Production' by Matthieu Saladin, cited below and published in Beatrice Gibson and Will Holder, *The Tiger's Mind* (London: Sternberg Press, 2012).

that matters. It is the condition of her listening – a future attentiveness that is already felt in Vibeke's manner of writing. It is there, shaping and directing her thoughts, moving her towards what can be thought and narrated. It was Bakhtin's contention that an utterance is 'linked not only to those preceding it, but also to those that will succeed it in the chain of verbal exchange'. And not only those recorded, but all the other parallel, criss-crossing channels and streams and currents of conversation, too. 'Each utterance', he wrote, 'refutes, affirms, supplements and relies upon the others, presupposes them to be known, and somehow takes them into account.'[II] These *Silent Whale Letters* are presented as an exchange between two artist-writers, Vibeke and Ella, yet they are exchanging with (refuting, affirming, supplementing and relying upon) so many other addressees, named and unnamed, human and non-human, including ourselves. Vibeke writes in Letter 19: 'Funny, I suddenly realise I'm responding not to your letter to me but to another text you recently wrote, which was echoing in your last letter!'

In a beautiful essay on Bakhtin's 'dialogism' and musical improvisation, the artist and researcher Matthieu Saladin writes: 'It's not the immediacy of the response in itself which gives it an active dimension – the active responsivity is at work in the listening, *whether it can be heard or not*. This response can therefore also be delayed, or "muted". It can manifest in different

ways and through different attitudes.'[III] The project is not to reply instantly. Not now, not out loud, not in the same mode, using the same language. Its aim is certainly not harmonisation. Rather, the idea – the work – is to make manifest the 'oblique movements and distances extending between different participating individuals, where heteronomy rivals with autonomy, convergence with divergence, agreement with disagreement'.[IV] O yes and also O no. Deep, focused engagement on the subject of a 'silent whale recording', and then all its veerings and its gaps. Saladin writes that such forms of collective production 'can be compared to a mountainous terrain emerging from the reciprocal emancipation of the different voices'.[V] A map composed not of fixed landmarks – not of Vibeke, sometimes at home in Den Hague; Ella, more permanently but also not in London; a sound recording logged in a national archive – but of moving, drifting, dispersed centres of being, non-being, and their complex, changeable interrelations. Such a map might be compared to a vast body of water, warm and cold, whose life forms call out to each other, vibrating the waters in ways that bounce off or actually enter one another. On rare occasions, their calls even land on land. To get at what Ella calls 'all our letters' dimensionalities', we would have to imagine this.

III Saladin, 'Between Affects', p.47.
IV Ibid., p.52.
V Ibid.

She Shelling

EMMA MCCORMICK GOODHART

When boundaries of our sleep and waking are gone there is only our music left ... Sleep to quicken your music ... It is Sweet Salt. [I]

Is it a bodiless you that listens to that bodiless voice? In that case, whether you actually hear it or merely remember it or imagine it makes no difference. [II]

In the wake of reading, I consider my way into the silent whale of these letters, a thought-buoy attended to by two writers for over three years. A shell ear is my own silent whale; a kindred artefactual riddle. Unburied in 1962 by Georges Bérard, a winemaker in France's dusty Cabasse, the artificial ear rested in soil(s) for some three millennia, adjacent to the trepanned skull of its

I Maryanne Amacher, program for *Eye Sleep, Ear Breath and Sweet Salt*, performance at The Kitchen, New York, 27 March 1972, The Kitchen Archive, http://archive.thekitchen.org/?p=14977, accessed 26 April 2023.

II Italo Calvino, *Under the Jaguar Sun*, trans. William Weaver (New York: Harcourt, 1988), p. 53.

female wearer. A mute and relic life form, radical in its improbability, it urges us to hear through, ear to the unground. To fathom without metric or timescale.

Emma McCormick Goodhart, *earamphore* (2022), 3D model rendered from archival documentation of the shell ear. Digitally projected as part of the artist's Nottingham Contemporary commission.

Sculptured from one half of the Mediterranean bivalve mollusc *Spondylus gaederopus*, this shell ear is a kind of scallop ('mineralogy, not morphology, makes resonance', the malacologist Geerat Vermeij, who is blind, tells me when I speak to him of this object). A shell that would have been dived for, then fashioned and, once body-worn – in luscious, hydrofeminine turn – would have rendered its adherent amphibian.

Somehow, this subaquatic auditory life form makes itself be believed.

In *Silent Whale Letters*, Vibeke Mascini and Ella Finer's exchanges-at-a-distance fabricate and fabulate a quantum kind of bivalve, too – one of frequency-hopping ('not heard, felt'), affective bandwidth attenuations and amniotic brine. Imaginaries thicken and thresholds (sonic, olfactive, haptic, oneiric) shift, adjusting their '[never]-so-silent' selves,[III] while we readers remain held in the sonar of their cross-currents. Spatially, they generate something of the fabric of sound artist Maryanne Amacher's 'long-distance music' in *Eye Sleep, Ear Breath* (1972), a listening experiment sited in two places at once, without 'electronic links'. Instead, 'our own soft-ware' codes interstitial concert here.[IV]

That we know provocative little of the conditions of the silent whale recording's making (a pretend antique, I now glean) – only that it represents the sole 'silent' recording in the British Library Sound Archive – incubates and unmoors, mollifies and makes extra-porous, the inquiring 'spanse of their correspondence.

Contoured by 'keeping faith in the absence of fact', just as whale speech-song eludes easy detection, resisting render or datafication, we are invited to speculate 'trace elements' together, in intimate tandem.[V] Anne Carson's adage 'to show the truth by allowing it to be seen hiding' permeates the spirit – in echolocative coax of what surfaces – of their exchange.[VI]

III Letter 2 in this volume: 'not-so-silent selves'.
IV Amacher, program for *Eye Sleep, Ear Breath*.
V Ella Finer quoted in Letter 2.
VI Anne Carson, *Nox* (New York: New Directions, 2010), n.p.

Quickly, their whale pluralises, untethers itself from its recording, and atomises into so many other phenomena.

I read these letters aware of my own relation to them, within them – that Ella found and read my work as she was writing, and that she shared this work with Vibeke.[VII] It is as if the three of us were already in orbit – another word for correspondence? – outside of time. As Ella finished her last letter to Vibeke, Letter 22, Ella and I met for the first time. I brought my cave perfume, created for an enviro-installation in an exhibition on subterranean imaginaries, to our meeting.[VIII] Notes include moonmilk (a microbial secretion), infused from skin-contact-style macerations, wet clay (or mitti attar), smeared mushroom gill, battery, unfiltered saké and chitinous cicada skin. Its effect: fumy, transparent, moist-cold, recessive, wet-plastery, unctuous, ozonous and iridescent.

In the scent, Ella smells spectres of the whale collections in the Natural History Museum's outstation: full of cetacean bone

VII Emma McCormick Goodhart, 'Underwater (Un)Sound', *e-flux Architecture*, www.e-flux.com/architecture/oceans/341778/underwater-un-sound, August 2020, and in Daniela Zyman, ed., *Oceans Rising: A Companion to 'Territorial Agency: Oceans in Transformation'* (London: Sternberg Press, 2021): on marine species modes of perception underwater, now in crisis – as *Silent Whale Letters* draws out – due to extreme anthropogenic acoustic load within acidifying oceans, where altered pH amplifies sound. Also see Emma McCormick Goodhart, 'Paleoacoustic Accommodation', *e-flux Architecture*, www.e-flux.com/architecture/positions/295380/paleoacoustic-accommodation, October 2019, on how Lascaux IV's 'synthetic material fiction' enables us to hear through 25,000-year-old sound.

fragments, long entombed, but still oily and unctuous, secreting in secret ('ink-black ... like charred wood', even 'wet to touch'; Letter 22). In Letter 20, she elaborates the whale room, sweet and dry in scent, like a cave, with textures she likens to 'pet shop' (courtesy of her prehistorian friend), leatheriness and sawdust.

Soil gets thrown into the mix, more troublingly, when Ella slips her hand into the cavity of a whale skull, painted black to disguise boneness. Residue from its time dug into the Natural History Museum's artificial sandpits to melt flesh, to make specimen, a technique used as late as 1939.

Yet bone fragments' oiliness resists their turning fossil 'matter', and real-time secretions sustain them as metabolic *matterings* instead. Not thing, but aura – like instances of osmogenesia, where (usually) sweet aromas are perceived to emanate from saints' bodies or bones, often at or after death, against normal smell registers of morbidity. Certain figures' sainthood is even consequent of posthumous sillage, a sensorial measure of holiness.

Kin prehension by emanation compasses Vibeke's Letter 19, where she recalls gleaning the presence of a stranded whale, on a beach near The Hague, via odour. 'Sweet and rotten like nothing else', she finds its body already occluded, withheld, incarcerated by a container, awaiting researchers and forensics who can learn more before tissue hardens. Prevented from looking, she telescopes in with her Motorola flip, which, PillCam-like, sees for her, but at imponderable rescale.

'The scale of an eye and the seen subject can be so widely other', writes Vibeke, 'that it can feel strangely puzzling how

one fits through the other, even by reflection.' Ella, in response, muses that 'the whale is the size of its smell' (Letter 20).

Nurtured throughout *Silent Whale Letters*, irresolvable riddles of scale (a planetary virus, a fragmentary bone, infrasonic frequencies contra the outsize vibrational life of whale song) in some way return us to that earliest site of hearing, by buoyant underwater proxy, while miniature in a multiscalar womb – a phenomenon that Vibeke and Ella wonder at in Letters 6 and 7. One that draws us near to the lived ontology of vibration and sound as such, which is always by contact – a kind of touch, however remote, of stimuli in sensing agent. A collapse of inside from outside.

What does it mean that we first 'hear' vibrations through liquid from the interior of another's body, just weeks after we begin to have a pulse at all? To be 'invaginated' within another's voice? To cohabit that voice's haptics?

It may, I imagine, feel something like the frequency-adjusted silent whale recording, shared with me as I write: all tympanum, airpulse, a delicate seizure of feathery palpitation, tuned to the incremental, anticipatory, dub-like beat of ontogenetic incubation.

To be at the beginning of the world.

I can hear the heart I have never seen.[IX]

IX Letter 14.

ELLA FINER's work in sound and performance spans writing, composing, and curating with a particular interest in how women's voices take up space; how bodies acoustically disrupt, challenge, or change occupations of space. Her research continuously queries the ownership of cultural expression through sound; often through collaborative projects centring listening as a practice of deep attention, affiliation and reciprocity. She is currently finishing her first monograph *Acoustic Commons and the Wild Life of Sound*, a work considering the inherent power in/of that which falls outside of administrative control – as a way of thinking through the sonic as critical agitator: how sound resists categorization in the archive; how sound makes and disperses knowledge beyond the bounds of the institutional building. She is co-chair of the Longplayer Trust (www.longplayer.org), and is affiliated with the Acoustic Commons network and project (www.acousticcommons.net).

VIBEKE MASCINI explores, through sculptures, installations, video and text, a scaling of abstract phenomena into a sensorial scope, with the intention to seek agency from intimacy. In long-term collaboration with scientists, engineers, government employees and musicians she proposes a conscious understanding of electric energy as a statement of interconnect-edness and entanglement – between species, media and nature, matter and energy. Her earlier publications include *The Dent of Walter Umenhofer* and *Cloud Inverse*, both independently published. Vibeke is currently an artist-in-residence at Rijksakademie in Amsterdam 2021–2023. www.vibekemascini.com

KATE BRIGGS is a writer and French-to-English translator based in Rotterdam, NL where she co-runs the reading, writing and publishing project Short Pieces That Move! She is the author of *This Little Art* and *The Long Form*, both published by Fitzcarraldo Editions.

EMMA MCCORMICK GOODHART is a postdisciplinary artist and theorist based between New York City and London, who experiments across media, timescales, and modes of practice. Interested in fathoming deep-time developments of sensing, especially in sound, alongside technosensory futures, she has presented work at Belmacz (London), Bergen Assembly (Norway), Glucksman (Cork), Haus der Kulturen der Welt (Berlin), Kunsthalle Zürich, Le Musée d'Art Moderne de Paris, Montez Press Radio (New York), Nottingham Contemporary (UK), Pioneer Works (New York), Storefront for Art & Architecture (New York), and The Merchant House (Amsterdam), among other sites. Her writing has been published by e-flux Architecture, Flash Art International, Frieze, Goldsmiths CCA, Kunsthaus Zürich, Luncheon, Open Humanities Press, PIN-UP, Sternberg Press, The 3D Additivist Cookbook, The Plant, and Vestoj, and has been shared with Adidas' FUTURE Lab. She was recently an artist resident at Stiftung Sitterwerk at Kunstgiesserei St. Gallen, Switzerland, and dramaturge for William Forsythe's inaugural sonic intervention at Kunsthaus Zürich in 2021.

ACKNOWLEDGEMENTS

Many people have made this project move and grow: they are numerous and their support more distinct than simply naming them together here can honour. We are deeply grateful to all those who have read the letters, who have responded, and continue to respond, in many and various ways. To this energetic paragraph of brilliant people, thank you: Canan Batur, Denna Cartamkhoob, Sheila Chukwulozie, Aaron Cezar, Stephen Cleary, Gillean Dickie, Eva Ebersberger, Ben Elliott, Marcia Farquhar, Jem Finer, Kitty Finer, Matthew Fink, Helen Gale, Raviv Ganchrow, Rebecca Giggs, Max Hales, Sammy Hales, Laura Harris, Tom Haines, Christopher Heighes, Barbora Horská, Lana Jerichová, Daniel Jones, Pamela Jordan, Eirini Kartsaki, Petra Linhartová, Ferco Mascini, Julia Mascini, Isabelle Mascini, Lia Mazzari, Michael Morris, Louise O'Hare, Flora Pitrolo, Will Prentice, Markus Reymann, Richard Sabin, Oscar Santillán, Aimee Selby, Urok Shirhan, PA Skantze, Cheryl Tipp, Salma Tuqan, Angeliki Tzortakaki, James Wilkes.

We extend our sincere, enduring thanks to Emma McCormick Goodhart, Chus Martínez, Astrida Neimanis, Pablo José Ramírez and Tanvi Solanki for their generosity of response-in-writing across the life-span of the letters.

And finally, to even begin to find words of gratitude for Kate Briggs and Joe Hales leaves us language stunned. We feel extraordinarily lucky this book has come into being with two people who care deeply about books. Kate's approach to writing, through a deep love for what language can do (amongst so much else) is astonishing, it is magic experiencing her work with words. Another kind of magic is Joe's sensitive and considered attention to detail in design, with a respect for the imagined reader of the book that is all too rare. Thank you Kate and Joe, this book would not be here without you.

We gratefully acknowledge the support of:
Sternberg Press, Sylvia, Rijksakademie Amsterdam,
Delfina Foundation, Nottingham Contemporary,
Infrasonica, the British Library Sound Archive and
the Natural History Museum, London.

Ocean-Archive.org and TBA21–Academy have supported this project in multiple ways. We are very grateful for the home Ocean-Archive.org provided and continues to provide: a space in which the letters are interspersed with responsive essays, unfolding evermore sites of correspondence. You can access this version of the letters along with voice recordings here:
 www.ocean-archive.org/story/
 silent-whale-letters

TBA21–Academy is TBA21's research center fostering a deeper relationship with the Ocean and other bodies of water through the lens of art to inspire care and action. Established in 2011, the Academy has since worked as an incubator for collaborative inquiry, artistic production, and environmental advocacy, catalyzing new forms of knowledge emerging from the exchanges between art, science, policy, and conservation. In 2019, the Academy launched two initiatives to share its research and practice with the wider public: the physical venue Ocean Space in Venice, Italy, and the digital platform Ocean-Archive.org.

Ocean-Archive.org is an online platform that investigates the potential of storytelling and transdisciplinary collaboration within and beyond archival practices. It strives to expand critical ocean literacy in a time of great necessity and catalyzes collective action for a living Ocean. The aim of Ocean-Archive.org is to bring together the multitude of voices and journeys around the Ocean and connect those striving to nurture and protect it. With ocean comm/uni/ty, the platform instigates conversations around the Ocean so that members can connect and co-create. Designed as a storytelling and pedagogical tool, Ocean-Archive.org translates current knowledge into a shared language that fosters synergy among art, science, policy, and conservation and enables us to make better decisions for urgently needed policies.
 www.ocean-archive.org

127

Ella Finer and Vibeke Mascini
Silent Whale Letters: A long-distance correspondence, on all frequencies

Published by Sternberg Press

Sternberg Press

Co-published with TBA21–Academy
 and Sylvia
With the support of Hinderrust Fonds

Edited by Kate Briggs
Copy edited by Aimee Selby
Proofread by Anna Roos
Design and print production
 by Joe Hales studio
Printed in Lithuania by KOPA

ISBN: 978-1-915609-02-1

The essay *Het Hart in Haar Mond* was first published by Infrasonica as part of *The Heart in Her Mouth*, December 2020.

IMAGE CREDITS:
p. 69: LOVE, at the end of the road, London, February 2021 © Ella Finer
p. 83: Whale jaw mould in Vibeke's studio, Rijksakademie, Amsterdam, May 2022. © Vibeke Mascini
p. 93: Launch of a Project MOBY DICK balloon at Holloman Air Force Base, New Mexico circa 1955. Licensed under Creative Commons by United States Air Force Public Affairs (Holloman Air Development Center)

All efforts have been made to contact the rightful owners for copyright and permissions. We apologize for any inadvertent errors or omissions.

T N Thyssen-Bornemisza
B Art Contemporary
A Academy

SYLVIA

tba21.org/academy
sylviapublishing.co.uk

ocean archive

Sternberg Press
71–75 Shelton Street, London WC2H 9JQ
sternberg-press.com